Seth Tupper brings his signature clarity, integrity and depth to the story of President Calvin Coolidge's summer in the Black Hills of South Dakota. This book could be written only by someone as drawn to the rugged potential of the hills as Coolidge himself. Tupper continues to be a writer to watch, yet in this work, readers are offered further glimpses into Seth Tupper's affection for the region as well as his nimble weaving of scholarship and storytelling.
—Lori Walsh, radio host and National Book Critics Circle member

Many people know President Coolidge spent the summer of 1927 in South Dakota's Black Hills. Seth Tupper tells how that decision came to be and gives a lively, highly readable account of the president's long vacation. Meticulously researched and documented, this is a book anyone interested in South Dakota history will want to read.
—Terry Woster, longtime South Dakota journalist and winner of the South Dakota Newspaper Association's Distinguished Service Award

Here's an entertaining story about a quirky U.S. president's convergence with the beautiful mountain oasis that we know and love called the Black Hills. Fortunately, it was written by a highly respected South Dakota journalist who appreciates our state's history and understands our people and places because this book is as much about us as it is about Calvin and Grace Coolidge. Readers will enjoy a doubleheader of presidential history and South Dakota boosterism at its best—the latter being a South Dakota character trait sometimes taken for granted in a state that carves mountains.
—Bernie Hunhoff, former South Dakota legislator and founder and editor at large of South Dakota Magazine

Thoroughly researched and gracefully written, Calvin Coolidge in the Black Hills *will satisfy the reader's appetite for knowledge about that special summer when the State Game Lodge became the president's base of operations. It's a great story well told.*
—Noel Hamiel, longtime South Dakota journalist and member of the South Dakota Newspaper Hall of Fame

CALVIN COOLIDGE
IN THE Black Hills

SETH TUPPER

THE
History
PRESS

Published by The History Press
Charleston, SC
www.historypress.net

Cover image: President Coolidge wears an eagle feather bonnet given to him by Sioux people in South Dakota. *South Dakota State Historical Society.*

First published 2017

Manufactured in the United States

ISBN 9781467119313

Library of Congress Control Number: 2016943508

To South Dakota

Contents

Contents

Acknowledgements

I wish to thank:

- Greg Dumais, formerly of The History Press, whose idea spawned this project, and everyone else at The History Press who was involved in publishing this book, including acquisitions editor Edward Mack and production editor Julia Turner.
- Jon Lauck, who was the first to encourage me to undertake this effort.
- Pat Roseland, who graciously supplied many of the images for this book.
- The Rapid City Public Library, for its Coolidge images, newspaper microfilm and fulfillment of numerous interlibrary loan requests.
- The archivists who assisted me with research, including those at the University of South Dakota, Dakota Wesleyan University, Amherst College, Vermont Historical Society and South Dakota State Historical Society.
- Everyone at the Hermosa United Church of Christ for sharing their Coolidge memorabilia and knowledge.
- My volunteer readers and editors, including Noel Hamiel, Korrie Wenzel, Ryan Tupper and Hillary Dobbs-Davis.
- And finally, my wife, Shelly, for her love, support and editing, and my children, Kaylie and Lincoln, for their patience while Dad spent so many mornings and weekends writing.

INTRODUCTION

"I Do Not Choose…"

For the forty-eighth consecutive morning, President Calvin Coolidge awoke in a bed 1,800 miles from the White House. It was Tuesday, August 2, 1927.

He stirred to life inside the State Game Lodge, a rambling, rustic, three-story, thirty-room structure rising up from a rugged foundation of rubble stones in Custer State Park. The veranda and the sleeping porches jutting from the upper floors gave the appearance of a place trying to welcome the outdoors in.[1]

Dawn broke still and gray and cool in the surrounding valley within western South Dakota's Black Hills, a pine-forested mountain haven protruding from the northern Great Plains.[2]

Inside the lodge, with its stone fireplaces and rooms adorned with animal heads and hides, the president went about his morning routine with the aid of servants. After waking at 6:00 a.m., he probably would have eaten some fruit, sipped coffee and taken a walk with a Secret Service agent in the brisk morning air.

Back at the lodge after the walk, the president would have shared a fuller breakfast with the First Lady. Their typical morning meal consisted of locally caught trout or pancakes and maple syrup with bacon. Their dogs usually got some of the bacon.[3]

"I have been president four years today," the president said to his wife, Grace, after they finished eating.[4]

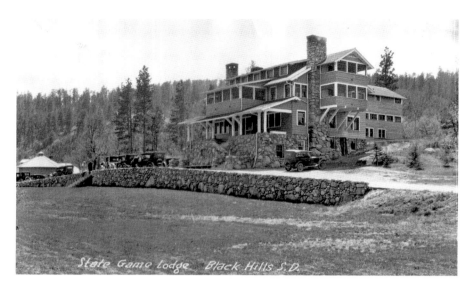

The State Game Lodge in Custer State Park, circa 1927. *Pat Roseland collection.*

It was the kind of cryptic remark that often passed as conversation with the nation's legendarily tight-lipped thirtieth president, known as Silent Cal, who turned fifty-five years old that summer. In the Black Hills, he found an environment similar to the wooded hills of his native Vermont, where he was given the name John Calvin Coolidge Jr. and grew up in the village of Plymouth Notch. After attending a private boarding school and graduating from Amherst College in Massachusetts, he settled in the nearby Massachusetts town of Northampton, where he apprenticed at a law firm and gained admittance to the state bar.

Soon, to the continual amazement of those who found him too impersonal and withdrawn for politics, he methodically climbed the ladder from city government to the state legislature. From there, he went on to become lieutenant governor and governor of Massachusetts and then vice president and finally president, winning the respect of voters with his no-nonsense approach. He was a strict conservative who believed government should do nothing more than necessary.

His conservative philosophy of government was matched by his conservative personal style. His lips were usually pursed in a dour frown, and he made people uncomfortable with his extreme silence in social settings. But he could also win them over with a well-timed quip. In one oft-repeated tale, a woman told Coolidge she had made a bet that she could get him to say more than two words. He reportedly turned to her and said, "You lose."[5]

When he stepped outside that August morning in the Black Hills, his slender, 5-foot, 10-inch frame was clothed in a business suit and overcoat, and his graying red hair was flattened and combed into a part. He inhaled the dry and pine-perfumed air at 4,200 feet above sea level, clean fuel for lungs weakened by illness in boyhood and a steady intake of cigar smoke in manhood. Across from the lodge, a creek babbled through the valley.

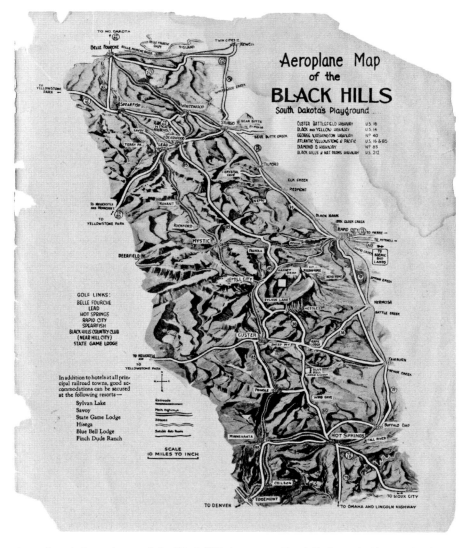

An early artistic road map of the Black Hills in western South Dakota. *Archives and Special Collections, University Libraries, University of South Dakota.*

The presidential limousine, a seven-passenger Lincoln sedan—something like a stretched Model T to the modern imagination—sat waiting with a driver to transport the president over thirty-two miles of muddy, gravel roads. He climbed inside and the limo puttered along, averaging about thirty miles per hour and snaking eastward and down out of the Black Hills and then north along the Hills' eastern flank to Rapid City.

The burgeoning town of about eight thousand residents served as a gateway to the nearly two thousand square miles of Black Hills mountains, forests, canyons and streams that were quickly becoming a playground for motoring tourists. Just eight days after this particular day's ride to Rapid City, the president would attend the commencement of carving on a mountain called Rushmore, which would accelerate the transformation of the Black Hills to a tourist mecca.

On this day, though, there were no outward clues of anything remarkable in the offing. By this eighth week of the president's vacation, his presence had become routine. The limo made its regular weekday-morning entry into Rapid City, where the conversion of streets from gravel to pavement was still a work in progress.

It was a place not long advanced from a frontier. Less than sixty years earlier, the Black Hills were a wilderness exalted by the Sioux people and reserved for their use. The gold rush that began in the 1870s changed that and forever fixed the Black Hills' place in western mythology, due in large part to Deadwood and its cast of colorful characters, including Wild Bill Hickock and Calamity Jane.

President Coolidge, who was born seventeen years before South Dakota became a state, had enjoyed some of the western character of the Black Hills during his long vacation. But today, there was business to conduct. Sometime prior to 9:00 a.m. local Mountain time, his limo parked at Rapid City High School, a three-story brick building situated on a rise at the southern end of downtown. A group of people stood outside the building hoping to see and greet him.

The president entered the building and went to his summer office, a converted French teacher's classroom with blackboards on three walls.[6] He handled some routine business items for perhaps ten or fifteen minutes and then welcomed about two dozen reporters into the room for one of his regular Tuesday and Friday news conferences.

Because it was the fourth anniversary of Coolidge's presidency (and therefore also the fourth anniversary of the death of former president Warren Harding, which had elevated then vice president Coolidge into the White House), a reporter asked the president to reflect on his accomplishments.

CAPITOL OF THE UNITED STATES DURING THE 1927 SUMMER VACATION OF PRESIDENT COOLIDGE

Rapid City High School, during the summer of 1927, when President Coolidge had his executive offices inside. *Pat Roseland collection.*

The president obliged in his typical businesslike and unemotional fashion, although he did go on a bit longer than usual. The country had avoided war, he said. The economy was doing well. Labor strife had been avoided. The national debt was down. Each of those points and others he explained in detail.

After about a half hour with the reporters, the president ended with a surprise.

"If the conference will return at twelve o'clock," he said, "I may have a further statement to make."[7]

The reporters retreated to gossip. It was the first time they could recall Coolidge ending a press conference with a request to reconvene later the same day.

For the next two and a half hours, the president received a number of visitors. Two Rapid City men gave him a vest trimmed in rattlesnake skin. South Dakota's chief justice, other dignitaries and some common citizens paid visits. A band from Watertown, a city on the eastern side of the state, performed outside and drew the president out to listen until a mist drove him back indoors. Dozens of onlookers waited on the high school grounds, hoping to see the president again.

At noon, the president welcomed the reporters back into his classroom office. He stood beside his mahogany desk with a cigar in one hand and a wad of small paper slips in the other, each one folded over on itself.

When the room filled and the door was closed, Coolidge asked if everyone was present. After receiving confirmation of that, he asked the reporters to pass by him one by one as he gave each a slip of paper.

Few people knew Coolidge well or could read his thoughts, least of all the reporters at that moment. Some later recalled him as grimly serious. Others wrote that he was visibly nervous or under deep emotion. Still others remembered him as faintly amused.

The looks on the reporters' faces, meanwhile, were easily interpreted as shock when they opened their folded slips of paper and read only this: "I do not choose to run for president in nineteen twenty eight."

One of the reporters asked if the president had any further comment. Some heard him answer "no" or "none." Others saw only a shake of his head.

Lest there be any doubt that the conference was over, a presidential staffer signaled it by opening the door. Reporters scrambled out, rushing to find the nearest communication device and transmit the news in time for evening editions of newspapers. Some reporters raced to the phones in the high school, some bolted for the town's telegraph office and some went to their own temporary summertime offices. By foot or by car, they hurried away.

The tourists and onlookers outside, who'd come only to see and hopefully speak with the president as he walked in and out of the building, stood dumbfounded as they witnessed the reporters dash out as though escaping a fire.

Some minutes later, the president emerged from his office, donned his overcoat and stepped back out into the cool, overcast day. He stopped briefly on the front steps with a group of Sioux people who'd come to see him and then hopped into the presidential limousine with Arthur Capper, a visiting U.S. senator from Kansas. Off the limo puttered again, back to the State Game Lodge.

"Such was the dramatic fashion," wrote a reporter that afternoon, "even spectacular by contrast with the simple manner by which it was disclosed, that an outstanding story was given to the country."[8]

Another reporter estimated that fifty thousand words were sent out over the telegraph wires from Rapid City that day to fill up the nation's newspapers.

The news stunned the country. Across the land that evening and the next morning, Americans read it in their papers and heard it on their radios and felt a collective bewilderment.

What in the world, they wondered, had happened out there in the wilds of South Dakota to provoke such a shocking announcement, and why had the president gone so far away for so long?

PART I

ANTICIPATION

1

FAILURE AND A FARM PROBLEM

When President Coolidge put his signature on the veto message of the McNary
Haugen Farm Relief bill, he touched off as heavily charged a current of political
electricity as has been let loose in national politics for years.
—*L.C. Speers,* New York Times[9]

Before succeeding in 1927, South Dakota made a failed attempt to host a presidential vacation in 1926.

Possibly the earliest evidence of that attempt is a letter dated March 10, 1926, from Albert M. Jackley, of Pierre, to William Williamson, who represented western South Dakota in the U.S. House of Representatives. The language of the letter indicates the two men had discussed inviting President Coolidge to the Black Hills. "There is no possible way in which our President or the Government could so forcefully show its appreciation of conditions in the west than by establishing the Summer White House in the Black Hills," Jackley wrote. "The inconveniences would undoubtedly be forborne cheerfully, and universally approved. You have a good case and I feel sure it will be well presented by you."[10]

Jackley's use of the phrase "conditions in the west" was probably a reference to the depressed crop prices afflicting farmers in the northern and western Great Plains. The "farm situation," as it was called, would eventually play a pivotal role in bringing Coolidge to South Dakota in 1927.

Jackley apparently had little to no further involvement in the presidential recruitment effort but went on to a modest measure of fame in later years

as the state's official rattlesnake eradicator. Coolidge, who reportedly had an intense fear of snakes, probably would have liked him.[11]

Another South Dakota man, Francis Case, claimed to have hatched the idea to invite Coolidge to South Dakota and also received popular credit for it, even though the only evidence to support Case's claim is a telegram he sent to Williamson twenty days after the Jackley letter. Case eventually served in Congress, but in 1926, he was the publisher of the *Hot Springs Star* newspaper in the southeastern Black Hills.

In Case's telegram to Williamson on March 30, 1926, Case noted press reports that said the chronically chest-congested Coolidge wanted a higher-elevation retreat with drier air for his 1926 vacation. Coolidge had spent his previous summer vacation in Swampscott, Massachusetts, following the long tradition of keeping the Summer White House relatively near the nation's capital.

"Press dispatches say President Coolidge will not return to Swampscott this summer, desiring mountains," Case wrote to Williamson. "Please present superior climate, temperate altitude, accessibility and communication facilities of the Black Hills, particularly the state park, and learn exact requirements. Confident associated commercial clubs and park board will provide whatever necessary to establish summer White House in Black Hills. Western summer home means much for entire country."[12]

By "state park," Case meant Custer State Park, roughly thirty miles north of Hot Springs in a beautifully rugged portion of the Black Hills.

Williamson honored Case's request and wrote a letter on April 1, 1926, inviting the president to South Dakota for the summer. Williamson enclosed two pamphlets about the Black Hills and a picture of the State Game Lodge.

In the letter, Williamson proudly described the mild climate, impressive scenery and abundant wildlife in the Black Hills and tried to spin a potential weakness—the relatively moderate elevation of mountains in the Black Hills, at least in comparison to the Rockies—into a strength.

"It is not so massive as to be overawing and oppressive," Williamson wrote, "but is sufficiently rugged to possess all the charms of the best mountain landscape."[13]

The president's executive secretary, Everett Sanders, whose duties were comparable to those of a modern chief of staff, replied with a brief note acknowledging receipt of the invite and saying only that it would be "given consideration."[14]

There were other places competing for the president's attention, and a national competition ensued. Some prominent South Dakotans, including

other members of the congressional delegation, called on the president personally to make their case.

"It soon became apparent, however," Williamson wrote, "that the President thought the Hills were too far from Washington for present consideration."[15]

Coolidge chose a spot in the Adirondack Mountains of New York and vacationed there during the summer of 1926.

South Dakotans, refusing to accept the finality of their defeat, turned their attention to 1927.

Opportunity in a Veto

As the new year dawned, a group of midwestern and western lawmakers known as the Farm Bloc pressed hard for congressional legislation to ease the economic suffering of their agricultural constituents.

American farmers had increased their productivity during World War I to replace waning European production. After the war, as European productivity recovered, American farmers continued to overproduce. They suffered plummeting prices as their supply outpaced demand.

The Farm Bloc's efforts to address the problem took the form of the McNary-Haugen bill, named for Republican sponsors Charles McNary, an Oregon senator, and Gilbert Haugen, an Iowa representative. The bill sought government intervention to raise American farm prices, in part by removing surplus crops from the U.S. market and dumping them on the international market.

The bill's momentum in Congress put the Farm Bloc on a collision course with the strictly conservative President Coolidge, who opposed aggressive government intrusion in the marketplace.

South Dakotans were well aware of the looming showdown and the opportunity it presented. Political commentators believed that if the McNary-Haugen bill passed and Coolidge vetoed it, an angry backlash among Farm Bloc lawmakers and their constituents would create a political problem for Coolidge in 1928, when it was assumed he was considering a run for reelection. If that scenario played out, Coolidge would need to do something to bolster his standing in farm country.

South Dakota legislators had that on their minds when they adopted a resolution on January 8, 1927, inviting Coolidge to the Black Hills for the summer. The resolution extolled the beauty of the Black Hills and included

a reminder, in anticipation of a McNary-Haugen veto and Coolidge's probable need to placate farmers, that "agriculture is prosecuted in the foothills and adjacent plains."[16]

The McNary-Haugen bill won final approval from Congress on February 17, 1927. Eight days later, on February 25, Coolidge vetoed the bill and excoriated it with a veto message so long that it ran to nearly eleven thousand words and spanned almost two pages in the newspapers that published it. The president called the bill, among other things, "an economic folly from which the country has every right to be spared."

As expected, the Farm Bloc fumed. Some Republican members spoke openly about supporting candidates other than Coolidge for the party's 1928 presidential nomination. The inner-party rift spelled trouble not only for Coolidge's reelection but also for the protection of the Republican majority in Congress.

The resentment Coolidge engendered among farm state Republicans was summed up by Arthur Krock, an editorial correspondent for the *New York Times*: "Politically they recognize in him a fellow Republican. Personally they admire Mr. Coolidge for individual excellences; but economically they look upon him as the leader of a faction either inimical or indifferent to their property interests and devoted entirely to protecting the prosperity of the East."[17]

That kind of sentiment continued to build as the Farm Bloc kept up its vengeful rhetoric. Then, on March 8, 1927, just eleven days after the veto, the White House announced that the president would go somewhere in the West for his summer vacation. It would be the first time a president had established a Summer White House in the West, and it was immediately interpreted as a political move.

"Some observers expressed the opinion that he was going out to get an idea at first hand of actual farm problems so as to overcome, if possible, some of the hostility aroused against the party and himself by his disapproval of the farm bill," the *New York Times* reported.[18]

Coolidge said nothing about his motives and did not reveal whether he planned to seek reelection in 1928. It was clear, however, that if he was still undecided about running, a trip to the West would allow him to gauge the extent of western opposition to his candidacy, or if he had already decided to run, the trip would give him a chance to campaign for the western votes he needed. Even if he had decided against running, the trip presented an opportunity to help the party by mending the rift between eastern Republicans and their Farm Bloc colleagues.

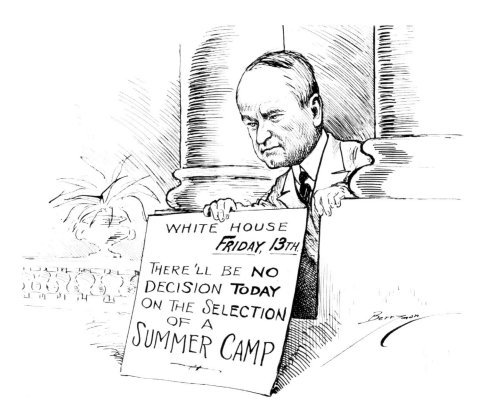

WHITE HOUSE
FRIDAY, 13TH.
THERE'LL BE NO DECISION TODAY ON THE SELECTION OF A SUMMER CAMP

The May 13, 1927 edition of the *Washington Evening Star* featured this cartoon by Clifford Berryman depicting President Coolidge. *National Archives.*

National attention turned to the intrigue surrounding the president's search for a suitable vacation spot. He wanted to go somewhere "on the Western borderland of the corn belt States," but he did not want to spend the summer on a hot, humid plain surrounded by farm fields and mosquitoes.[19]

There was no place better situated than the Black Hills of South Dakota to deliver the unique combination of mountains, moderate temperatures, freedom from insects and close access to farmers that the president coveted.

Agriculture was not abundant in the Black Hills, but farmers and ranchers tried to scrape out a living on the surrounding plains of western South Dakota, northwestern Nebraska, northeastern Wyoming and southeastern Montana, a four-state region where a dry climate and less arable land made the effects of depressed crop prices especially severe.

South Dakota was the epicenter of the agricultural depression. The state suffered a 62 percent decline in the total value of its crops between 1919 and

1926, the sharpest drop among all the farm states. South Dakota was also geographically centered among the states considered to be hotbeds of Farm Bloc support, a swath of the country that stretched roughly from Idaho to Wisconsin and from North Dakota to Oklahoma.[20]

So it seemed that South Dakota was a logical spot for a Summer White House. But could a president effectively conduct the nation's business so far from Washington, D.C.? That was an open question, and South Dakota had been passed over by Coolidge in 1926 because of that very concern. The president needed convincing, and South Dakotans had the man for the job.

2

A POLITICAL PARTNERSHIP

I have urged his coming to the state so hard that I have nearly worn out my welcome.
—U.S. senator Peter Norbeck, South Dakota[21]

South Dakota's senior U.S. senator Peter Norbeck seemed more likely to join the Farm Bloc revolt against Coolidge than to invite him to the Black Hills.

Norbeck fervently supported farmers and the McNary-Haugen bill, and he disliked Coolidge even before the McNary-Haugen veto. Norbeck campaigned against Coolidge's nomination in 1924 and was so effective that the then vice president finished second that year in South Dakota's six-way Republican presidential primary.

The distance between the two men was a result of fundamental differences in their backgrounds, political philosophies and approaches to governing. Besides their membership in the Republican Party, they had little in common.

Norbeck was a well-driller by trade, the son of Scandinavian immigrant parents and a stout, mustachioed, progressive man of action who idolized Theodore Roosevelt. When Norbeck scrutinized the slight, reserved, conservative Yankee lawyer in the White House, Norbeck saw someone who could "no more run this big machine at Washington than could a paralytic."[22]

But Norbeck was a savvy politician with a commitment to getting things done, and by 1927, he'd figured out how to work with Coolidge. The lesson was learned in 1925 when Norbeck visited the White House to seek the nomination of a political ally to the post of U.S. marshal for South Dakota. Coolidge listened to the request in his quiet way and then said only that his recent veto

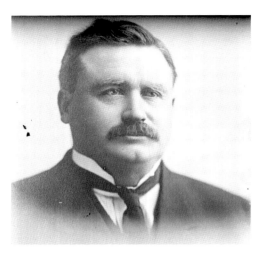

Peter Norbeck, circa 1915–20. *George Grantham Bain Collection, Library of Congress.*

of a bill to raise postal worker pay would soon be up for an override vote in the Senate. Norbeck took the hint. He cast a crucial vote to preserve the president's veto, the Senate upheld the veto by a one-vote margin and Norbeck's ally was eventually appointed U.S. marshal.[23]

So, by the time of the McNary-Haugen veto, Norbeck understood that working against Coolidge, as Norbeck had done in the 1924 campaign, was futile. It was better to engage the president in a little "Yankee horse trading."[24]

Each man had something to gain. Coolidge wanted a western trip to study and possibly repair the political damage done by his McNary-Haugen veto, and he also wanted a relaxing vacation in a high, dry, bug-free environment. A vacation in the Black Hills provided an opportunity for both, but the region lacked the telecommunications and other infrastructure needed to accommodate a working vacation.

Norbeck, who had enormous influence in South Dakota, could orchestrate the work necessary to accommodate the president. In return, Norbeck saw an opportunity to soften Coolidge's stance against the McNary-Haugen bill.

Norbeck also knew that a presidential vacation would generate priceless publicity for the Black Hills, which stood to benefit economically from the nation's budding automobile tourism industry. Additionally, Norbeck and a handful of other South Dakotans were struggling to raise money to begin a carving project at Mount Rushmore. A presidential visit might boost those efforts.

Norbeck's support of the 1926 effort to bring the president to South Dakota had been lukewarm, but now he launched the 1927 effort with gusto.

"Mr. Norbeck is a quiet, middle-aged gentleman," wrote the *Chicago Daily News*. "But when he goes after anything, whether it is water for the dry homestead, consideration for the farmer in the United States Senate, or selection of what he believes the most beautiful place in the world where the president may rest, Peter Norbeck is insistent."[25]

There were several additional factors in Norbeck's favor as he began his presidential recruitment project. Those included the ongoing national expansion of airmail service, which helped ease the president's concern about the distance between the White House and the Black Hills; a major White House renovation project that was scheduled to displace the Coolidges from the residence all summer; and the president's familial curiosity about South Dakota, where he had cousins descended from an ancestor who'd moved west from Vermont in the 1800s.

Still, the president needed to be shown that the Black Hills was both a good place for a vacation and one that could handle everything a presidential visit entailed.

Norbeck enlisted the help of his colleague William Williamson, the Republican U.S. representative from South Dakota who had tried to bring Coolidge to the Black Hills in 1926. Williamson had a closer personal relationship with the president than Norbeck.

Norbeck and Williamson knew it would be unwise to pester the antisocial president with a hard sell. So they began a soft campaign, designed at first to ensure the president knew the Black Hills could provide a restful retreat. In early April, Williamson had some pictures of Black Hills scenes enlarged, colored like oil paintings and artistically framed. He and Norbeck took two of them to the White House and presented them as gifts to First Lady Grace Coolidge. They were pleased to learn she had read some booklets about the Black Hills that Williamson sent her earlier.

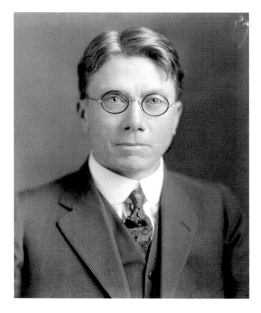

William Williamson in an undated image. *Harris & Ewing Collection, Library of Congress.*

Grace's interest in the Black Hills may have been piqued previously by her friend Lydia Norbeck, wife of Peter. The two women were acquainted in 1920 at a national meeting attended by their then governor husbands. Soon afterward, in 1921, both couples came to Washington when Coolidge became vice president and Norbeck became a senator.

Grace, whose husband presided over the Senate, was expected to preside over meetings of the Senate Ladies Club and did so with the charm that eluded her husband. Lydia Norbeck liked her immediately.[26]

The two women developed a friendship that persisted through Peter Norbeck's 1924 opposition to Calvin Coolidge's presidential candidacy and far beyond. Long after the Coolidges' summer in South Dakota, when Grace's second grandchild was born in 1939, she wrote to Lydia Norbeck to inform her that the child would share Lydia's first name.

In mid-April 1927, with Grace and Lydia possibly exerting influence behind the scenes, Williamson went to the White House for a meeting about business unrelated to the president's summer plans. At the end of the meeting, Williamson rose to leave but was stopped by Coolidge.

"When," Coolidge asked, "does the snow disappear in your state?"[27]

Clearly, the president was thinking seriously about South Dakota. Williamson said the snow in the Black Hills would most likely be gone by the expected mid-June date of the president's departure from Washington, D.C. Coolidge then asked why the Black Hills would be a good place for his summer vacation.

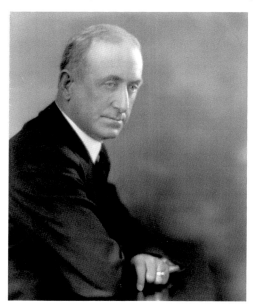

An undated image of Edmund W. Starling, the chief of President Coolidge's Secret Service detail during the first couple's 1927 summer in the Black Hills. *Harris & Ewing Collection, Library of Congress.*

Williamson reiterated the pitch that South Dakotans had been making since the previous year about the region's warm days, cool nights, dry air, lack of mosquitoes, natural beauty and abundant wildlife.

The president said he would send a man out to have a look. That man was the president's Secret Service attendant, Edmund Starling.

The Black Hills was not the only place in the running. Locations in Michigan, Wisconsin, Minnesota, Iowa and Colorado were said to be under consideration, and Starling left Washington in early May for a tour of all the potential Summer White House sites.

Starling arrived in the Black Hills on May 12, having already

toured a spot in Wisconsin. He motored around Rapid City and Custer State Park and stayed a night in the State Game Lodge before heading out for Colorado. He arrived back at the White House on May 19 and recommended the Black Hills.

"You can fish all day," Starling told the president. "You'll sleep well at night, and you can ride into the Executive Offices at Rapid City three or four times a week. You'll come back to Washington a new man."[28]

Starling apparently gave a similar report to Norbeck but expressed concerns about accommodations, amenities, infrastructure and communications. Norbeck knew that Starling and Coolidge were on the hook and needed only to be reeled in. The senator sprang into action, shifting the work to accommodate the president into high gear and making daily visits to the White House throughout late May to answer questions and relay instructions back to South Dakota.

Norbeck practically became the president's travel secretary. During the two weeks following Starling's return to Washington from the scouting trip, dozens of telegrams and letters about the presidential arrangements flew in and out of Norbeck's office. No detail was too small to escape the senator's attention as he investigated, among other things, spaces for the presidential offices, installation of adequate communication equipment, the linens and dishware at the State Game Lodge, offers of a free grand piano and record players for the first couple's use, accommodations at the lodge and elsewhere in Custer State Park for the president and his staff and accommodations for additional staff and the presidential press corps at Rapid City hotels and private homes.[29]

As the president's visit became more certain and word of its likelihood leaked out, Norbeck acted as a shield to protect Coolidge from a torrent of eager invitations. Dozens of people from all over South Dakota sought the senator's help in bringing the president to their town for an appearance or speech, but Norbeck deflected most requests, making many requesters think he was lobbying hard on their behalf when in fact he was helping the president avoid overscheduling.

"I have received and forwarded to the president many requests and have urged him to visit Sioux Falls," Norbeck wrote in one craftily worded piece of correspondence, "but believe he is anxious to get to the lodge for some rest and recreation and will not stop anywhere en route. Confidentially will state that I have urged his coming to the state so hard that I have nearly worn out my welcome. I cannot insist on any more."[30]

Coolidge, still having made no formal public announcement of his intentions for the summer, let it be known that he was leaning toward the

Black Hills and dispatched Starling back to the state in late May for another scouting trip. Starling apparently reiterated his earlier favorable report. On May 31, the White House finally announced that Coolidge would vacation in the Black Hills and would arrive in mid-June to take up residence at the State Game Lodge in Custer State Park.

Starling remained in the Black Hills to monitor preparations, which had tentatively begun but now had to be sped up and finished in a couple of weeks.

"The announcement naturally created more or less consternation," wrote John A. Stanley, secretary of South Dakota's State Park Board. "It meant what seemed to be a stupendous task to prepare for such an auspicious event in so short a time."[31]

3
ROLLING OUT THE GRAVEL CARPET

It seemed that an endless task was suddenly placed upon those in authority at the State Park.
—John A. Stanley, secretary, South Dakota State Park Board[32]

A news story in the May 31, 1927 edition of the *Rapid City Journal* put the challenge of preparing for a presidential visit in perspective.

"A year's development program for Custer State Park, summer home of President Calvin Coolidge," the story said, "was under way today at a speed that promised completion within three weeks."[33]

An estimated $52,000—about $700,000 in inflation-adjusted 2017 money—was requested from the legislature to fund work that had already begun in Custer State Park and to compensate the State Game Lodge concessionaire for vacating the lodge and twelve cabins for the summertime use of the presidential party.[34]

The tranquility of the park erupted into a cacophony of sawing, hammering and all manner of renovation work. The exterior of the State Game Lodge was painted and the interior redecorated with new furniture. Because the takeover of the lodge by the president and his staff would leave no place to accommodate other daily visitors to the park, a crew of about thirty men was enlisted to work day and night, and sometimes through the rain, to build a 3,500-square-foot dining hall near the lodge that came to be known as the Game Lodge Inn (and later was renamed the Coolidge Inn).

Elsewhere in the two-hundred-square-mile park, workmen finished a road to the peak of 6,023-foot Sheep Mountain, about twelve miles from the Game

Lodge, and built a lookout tower atop it. A few weeks later, after the president's arrival, the state legislature voted to rename the peak Mount Coolidge.

About fifty soldiers were selected from Fort Meade, some sixty miles north of Custer State Park on the northeastern outskirts of the Black Hills, to spend the summer working as presidential guards. Fourteen trucks were needed to haul them and all their luggage and equipment. In addition to the soldiers, the state police sent five motorcycle cops to patrol the Black Hills during the president's stay.

A special train arrived with several carloads of telephone-line material and equipment, to be installed by two hundred men. They strung copper telephone wire over the more than two hundred miles between Rapid City and a transcontinental circuit in Sidney, Nebraska. The workforce in the Rapid City telephone exchange was increased to more than thirty operators, and a private exchange consisting of thirty wires was installed at Rapid City High School.

In other work at the high school, which had been selected to house the summer offices of the president and his staff, eight classrooms were cleared of students' desks and reserved for the use of the executive force, as was the teachers' lounge. The White House shipped in a big mahogany desk for the room that would serve as the president's office and commandeered teachers' desks for the other offices.

Four units of the latest and greatest telegraph model, known as the multiplex, were installed at the Western Union office in Rapid City. The machines could each transmit up to eight messages over one telegraph wire simultaneously. Outgoing messages were keyed in by operators, and incoming messages were printed by automated typewriters.

On the streets of Rapid City, up to eight wagons and a truck were used for several days to haul rubbish from alleyways and spruce up the city. The *Rapid City Journal* acted as a clearinghouse for a dandelion eradication campaign, inviting residents to hire from a pool of one hundred grade school and high school students who offered to dig dandelions for twenty to twenty-five cents per hour.[35]

The massive scale and pace of the preparations was intoxicating to the people of the Black Hills but was frustrating for some in the nation's capital.

"President Coolidge's quest for isolation in the Black Hills of South Dakota has enmeshed the White House staff in one of the most complicated and difficult tasks it has had to perform in a generation," griped the Associated Press. "The multitudinous preparations to assure his comfort and keep him in touch with the affairs of the government and

the outside world during his summer in the Hills are costing a continuous outlay of patience, time and money."[36]

The story did not include a tally of costs but said the price to string one telephone wire across a rugged stretch of the Black Hills exceeded $10,000.

An editorialist for the *Rapid City Journal* sniped back at the easterners.

"Migosh, some of those eastern news writers are showing ignorance!" the editorial said. "You'd think to read their stuff that after Coolidge left Chicago he'd have to take a covered wagon, and they'd have to walk. They have some revelations waiting for them here."[37]

South Dakotans were making their own great outlays of time and money but were happily anticipating the future reward of increased tourism, both during and after the president's vacation.

Perhaps no project undertaken in preparation for the president's visit required as much determination to complete or proved so nearly catastrophic as the hurried effort to upgrade a ten-mile stretch of dirt road between the State Game Lodge in the Black Hills and the small town of Hermosa on the Hills' eastern edge. It was a section of road that President Coolidge's limousine would have to navigate daily while transporting the president back and forth between the lodge and his office in Rapid City, and the road was in such poor shape that it was sure to be impassable after a rain.

Starling, the Secret Service man, had urged upgrades to the road while on his tour of potential Summer White Houses in early May. When he came back to the Black Hills at the end of May to monitor final preparations, he was surprised to find nothing had been done to the road. He met with the state Highway Commission and issued an ultimatum: Unless the road was improved and graveled by June 15, the president's trip would be deferred.[38]

The state's Democratic governor, William Bulow, was scared into action. The state highway engineer and highway commissioners told him the ten-mile stretch needed surveys, plans, specifications, blueprints and grading. Then the grade ought to be allowed to settle, they said, before the gravel was put on. The work could not possibly be completed in the two weeks available.

"I told them that it had to be done before the President came," Governor Bulow wrote later. "If they could not do it, I had an Irish friend living at Beresford who had done a lot of railroad grading; that he was out of a job at present; that I would send for him and have him come up and grade and gravel the road."[39]

The highway engineer and commissioners got busy. Trucks began rolling to the Black Hills, and as Starling later recalled, they got stuck in some mud and had to be

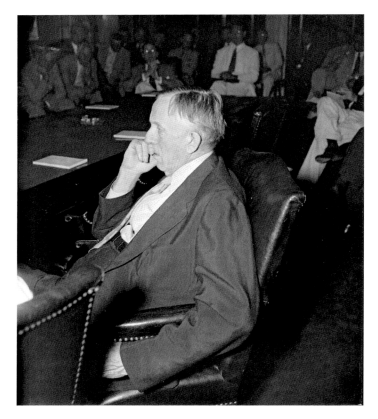

William Bulow in 1939 in Washington, D.C. *Harris & Ewing Collection, Library of Congress.*

transported the rest of the way by train. Workers dug a gravel pit but found it contained insufficient gravel for the job, so they hurriedly dug another one.

With the help of eighteen trucks and up to seventy-five men working at a frantic pace, the road was reportedly finished on June 15, the day of the president's evening arrival.[40]

"The President drove over it every day for many weeks," Governor Bulow wrote years later, "and never knew but what the road had been properly surveyed; he doubtless always supposed that it had been built according to plans and specifications."[41]

4

THE WHITE HOUSE GOES WEST

It is the first time the president has planned such an extended trip in so comparatively a remote section of the country…
—Associated Press[12]

When the day of departure finally arrived, the Coolidges set out for a vacation that would prove historic in distance and duration. Never before had a president gone so far away from Washington, D.C., for so long.

The first couple boarded a nine-car train at 9:00 p.m. on Monday, June 13, with luggage to last until August or September.[13] Roughly eighty people made the journey west, including government aides, household servants, correspondents for newspapers across the country and photographers. Even the Coolidges' two collie dogs, Rob Roy and Prudence Prim, and pet raccoon, Rebecca, came along.

"Pending good behavior," said a newspaper account, "the pets rode in the president's car, Rebecca occupying a comfortable basket."[14]

The train rolled through the night with the Coolidges sleeping in the rear car. Beyond short stops for train maintenance or to pick up or drop off dignitaries, there were only two official events planned during the trip: one at Hammond, Indiana, and the other at the South Dakota capital city of Pierre.

The train arrived at Hammond, in the Greater Chicago area, on the afternoon of Tuesday, June 14. The president disembarked and was paraded through the streets to Wicker Memorial Park, where a huge crowd estimated in the tens and even hundreds of thousands listened to him deliver a speech and dedicate the park in honor of World War I veterans.

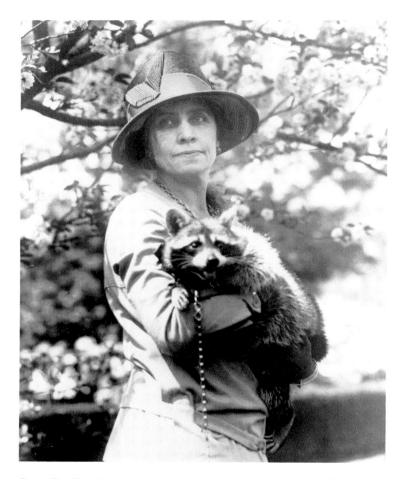

Grace Coolidge brought her pet raccoon, Rebecca, seen in this 1920s image, on the first couple's vacation to the Black Hills in 1927. *National Photo Company Collection, Library of Congress.*

After two hours in Hammond, the train headed west again. The Coolidges waved from the platform of their train car at crowds gathered along the route, until day faded into night. They passed some time aboard the train watching newsreel footage of Charles Lindbergh's recent transatlantic flight and then spent the night in their sleeping car again as the train roared across the prairies of southwestern Wisconsin and southern Minnesota.

Even before the Coolidges awoke the next morning, Wednesday, June 15, groups of people were gathered in the predawn light at crossroads in rural southwestern Minnesota to watch the presidential train go by. The

Coolidges' head housekeeper, Ellen Agnes Riley, described the scene in a letter.

"At every cross-road a group of people to see the President's train go by," she wrote. "You can't comprehend what that meant to these people. I was awake early, perhaps four o'clock and that early there were groups of three or four with a small American flag, standing in the gray light waving a welcome. They all looked so poor, and the women so drudge-worn. I was sorry for them."[45]

As the sky lightened, the Coolidges went out on their train car platform again, waving to crowds assembled along the tracks. The train crossed into South Dakota after sunrise and stopped at the small town of Elkton, where Senator Norbeck boarded with about thirty political allies he'd negotiated to bring aboard.

The usually stoic president was reported to be "as happy as a schoolboy and was in constant smiles."[46] He was probably high on adulation and maybe even feeling smug about the adoring crowds that continued to gather in small towns along the tracks. If the people of the Great Plains were angry and fomenting political revolt over the president's veto of the McNary-Haugen farm bill, they sure weren't showing it.

Norbeck told a newspaper correspondent that although the mood on the plains had been lifted by a wet spring, there was still a great demand for government help to boost crop prices. But the tone of the trip was firmly established in those first hours in South Dakota. On the topic of the McNary-Haugen bill, Norbeck would find himself playing defense all summer long as the wet weather continued, the crops grew tall and star-struck legions clamored to fawn over the president. A popular desire for legislation to boost farm prices remained, but Coolidge controlled the conversation and ended up backing a more conservative farm bill later in the summer.[47]

The presidential train crossed South Dakota's eastern prairies via the Chicago & North Western line, which cut through the middle of the state's north–south expanse. Norbeck and the White House staff had considered a route on the Milwaukee Road across the southern part of the state so the president could stop at the small town of Fulton to visit some long-lost cousins and see the grave of his great-uncle, Milan Brewer. Brewer died in 1925, having come west to South Dakota after his father, the president's great-grandfather Israel Chase Brewer, had moved west to Wisconsin from Vermont.[48]

It was decided that the extra stop at the Brewer grave would push the Rapid City arrival too late into the evening. The Brewer cousins, adult

children of Milan Brewer, ended up visiting Coolidge later during the summer in the Black Hills.

On the Chicago & North Western route across eastern South Dakota, the train traversed land ranging from flat to gently rolling, with glacial lakes, small farms and small towns built around railroad depots. The train slowed as it passed through the towns, many of them decorated with American flags and some with bands playing as excited crowds cheered and waved.

The train stopped briefly around 9:00 a.m. for a scheduled locomotive switch at Huron, one of the biggest of the small towns in eastern South Dakota. A crowd estimated at half the size of the town's roughly ten thousand residents stood shoulder to shoulder around the depot as a drum and bugle corps played, and small twin girls presented the Coolidges with flowers.

The group of Senator Norbeck's cronies who boarded the train near the eastern state line left the train at Huron to head back home. So did a stray elderly man, who had somehow gotten on the train at Elkton despite not being on the list of approved passengers. He wanted to see "Mr. Coolidge," he said, and was allowed a brief visit.[49]

A second group of Norbeck cronies boarded at Huron for the ride farther west to the state capital city of Pierre, where the north–south flowing Missouri River divides the state into eastern and western regions and the fertile, tidy fields of the Midwest give way to the sprawling, semiarid rangeland of the West.

The train pulled into Pierre (which South Dakotans pronounce like "peer") around midday, and the urbane easterners aboard it clashed immediately with their western hosts.

"This sure is a cow town," said one newspaper correspondent as he stepped off the train and walked toward a line of motorcars that stood ready to transport the presidential party to the state capitol building. The correspondent, seeing his assigned car and a man standing beside it, took the man for a chauffeur and tossed him a dime. The "chauffeur" was actually Charles L. Hyde Jr., member of a Pierre millionaire family, director of two banks and owner of a string of polo horses. He had volunteered to drive one of the cars in the presidential caravan.

"He kept the dime," deadpanned the Associated Press reporter who recounted the incident.[50]

The president and Mrs. Coolidge also climbed into open-air motorcars, and the caravan drove to the capitol building on streets lined with thousands of cheering people.

South Dakotans were eager to show off their capitol. The copper-domed structure, completed just seventeen years earlier, rose 161 feet above the

little railroad town that surrounded it. The sight of the capitol's grand staircase, columns and limestone walls must have seemed like a mirage to the Coolidges, who had gazed out from their train at a declining number of trees, towns and people since their stop in Huron.

After passing through a throng on the steps and inside the entryway, including a man who gave the president a ten-pound buffalo steak, the Coolidges went to the governor's reception room inside the capitol and quickly received a line of about one hundred state and local officials and their spouses.[51]

The Coolidges and several local and state dignitaries and their spouses then left the capitol building and got back in their open-air cars for the return drive to the train. South Dakota governor William Bulow, a Democrat, rode with the Republican president.

Bulow had been underwhelmed by the president's appearance earlier when he had boarded the president's train to greet him.

"No one had ever told me that the President had red hair; no one had ever described his size to me, and I thought he looked rather small in stature to be a President," Bulow wrote later. "I expected him to be more dignified and more important-looking."[52]

The president's appearance may not have intimidated the governor, but the president's silence certainly did. Coolidge said nothing as the open-air car drove away from the capitol until the car took some unexpected turns. The day was hot and windy, Bulow reported later, and the air was filled with windblown particulates from Missouri River sandbars and dusty streets.

Coolidge seemed annoyed.

"What are we going down here for?" the president asked the governor.

Bulow explained that Pierre's mayor, who was riding in another car, wanted to show off the city park. Coolidge said nothing more, and Bulow grew uncomfortable with the silence. But he figured it was best to avoid speaking until spoken to.

After a while, the president asked another question.

"How do you enforce the Prohibition laws in your state?"

Now Bulow grew extremely uneasy. Prohibition was the law of the land but was disobeyed by large segments of the American public. Bulow did not know the president's personal views and wondered whether Coolidge was making an honest inquiry or hinting for a drink.

Showcasing a politician's knack for ambiguity, Bulow quickly struck upon the perfect answer. How did he enforce Prohibition? "Pretty well," he said, "but not absolutely."

Again the president fell silent.

Then, as the line of cars got near the depot, the president piped up to ask the population of Pierre. Bulow said it was about 3,500.

"Well, they must be about all out," the president said.

The drive from the capitol to the train took fifteen minutes, Bulow later reported, and Coolidge's few questions and Bulow's few answers composed the entirety of their conversation.

With the Coolidges back aboard the train, it left Pierre, chugged across the Missouri River bridge and climbed up the river's western bluffs. Here the West began to open up in all its expansive glory, as the vast, treeless plains spread out under a massive sky and farm fields faded into waving stands of grass.

The towns along the two hundred miles from Pierre to Rapid City were small and isolated. Later that week, during one of Coolidge's regular press conferences with reporters in Rapid City, he expressed his disappointment about how the well-worn dirt around so many of the small-town train depots had blown up in a haze as his train passed through.

"Oftentimes I would go out on the back platform to see the people that were standing at the station and all I would be able to see when I got out there was a cloud of dust," Coolidge said. "I couldn't see them and I suppose they couldn't see me."[53]

There would be plenty of further opportunities for Coolidge and South Dakotans to see each other. By late afternoon, with the train whittling away the last of the trip's 1,800 miles, the dark outline of the Black Hills would have been visible on the horizon. Finally, the long journey was ending and an unprecedented presidential adventure was beginning.

"Now the people of the West, at least a part of them, are to have a close-up of President Coolidge," said the *Washington Star*. "They may be the better able to get his point of view, and he theirs."[54]

A Grand Arrival

*It was one of the most beautiful scenes that has ever unfolded itself
to President Coolidge.*
—New York Times[55]

T he president's train pulled into Rapid City, at the foot of the Black Hills, at 5:30 p.m. on Wednesday, June 15. It was a cool, overcast day with a high temperature in the fifties and periods of drizzle interrupted by brief rays of sunshine.[56]

One later chronicler remembered that the sun burst forth and shone brilliantly just before the president's train arrived, but that memory might have been colored by the excitement of the occasion. Another account also mentioned the sun emerging dramatically, but not until the president was on the road to the State Game Lodge.

Whatever the actual condition of the sky, excitement was sky high and all eyes were focused on the presidential train as it slowed to a stop alongside the depot near Ninth and Main Streets. National Guardsmen held back the crowd while a local welcoming committee prepared to greet the president. The White House servants disembarked first and began loading luggage into waiting trucks and buses while presidential staffers, newspapermen, photographers and others of the eighty-member party deboarded the train.

Edmund Starling, of the Secret Service, brought Rapid City's mayor and commercial club president aboard the train to meet President Coolidge. A few minutes later, when the president finally stepped out on the rear platform of his railcar, he was immediately startled by a series

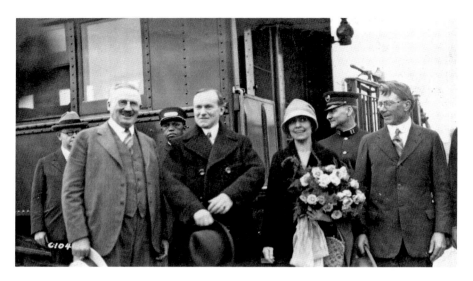

The first couple, after disembarking the train at Rapid City, with Senator Peter Norbeck (*left*) and Congressman William Williamson (*right*). *A.B. Kellogg Scrapbook, Rapid City Public Library.*

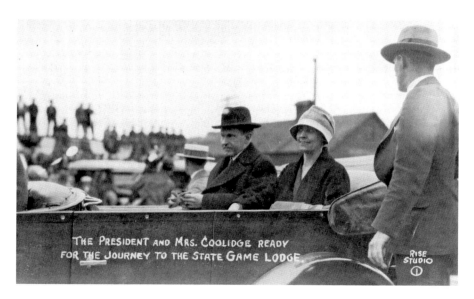

The president and First Lady wait to be driven to the State Game Lodge after arriving by train in Rapid City. *Rise Photo, Pat Roseland collection.*

of salutatory shots that boomed out from four National Guard cannons placed nearby. The blasts shook the ground, surprised the spectators and sent pigeons flapping wildly overhead.

The president made a quick recovery. Wearing a long, dark coat over his business suit and holding a fedora, he stepped down onto the station platform amid the cheers of the restricted throng that was straining to see him. The First Lady followed in her own long, dark coat and a light-colored, fashionable hat. They smiled as they shook hands and posed for photographs with members of the welcoming committee, who gave Mrs. Coolidge a large bouquet of roses.

The first couple climbed into an open-air automobile parked at the head of a line of about ten vehicles near the train. The caravan drove about a block south and turned east onto Main Street, where a crowd of cheering people estimated between seven and ten thousand—businessmen, mothers, children, cowboys, miners and others—stretched along both sides of the street for ten blocks and welcomed the Coolidges like latter-day rock stars. American flags hung overhead, affixed to wires stretched between the rows of two- and three-story brick buildings. The president stood up in the car periodically to doff his hat and acknowledge the cheers while Mrs. Coolidge waved happily from her seat.

As the caravan inched along, some members of the crowd rushed back to the alleyways and ran several blocks ahead, hoping to squeeze through the crowds along Main Street for a second glimpse of the president and Mrs. Coolidge.

"It was a distinctive crowd, free from any attempt at style," a *New York Times* correspondent haughtily observed, "but bubbling over with hospitality and good cheer."[57]

The caravan turned south for a block at Maple Avenue and then east again on the road that led out of town. Near the South Dakota State School of Mines along the city's eastern fringe, the Coolidges got out of their open-air car and into the enclosed presidential limousine, which sped up and headed south on the gravel highway toward Custer State Park and the State Game Lodge. Out there in the countryside, the vast plains sloped away and downward toward the eastern horizon as the Black Hills rose up in the west, their rocky peaks jutting from pine-covered slopes.

After about fifteen miles, the caravan arrived at the village of Hermosa, where one hundred cowboys on horseback greeted the president and led his caravan through town. Just south of Hermosa, where a clear creek bubbles out of the mountains and onto the plains, the riders peeled away and the caravan turned west to follow the creek up into a winding canyon. The car

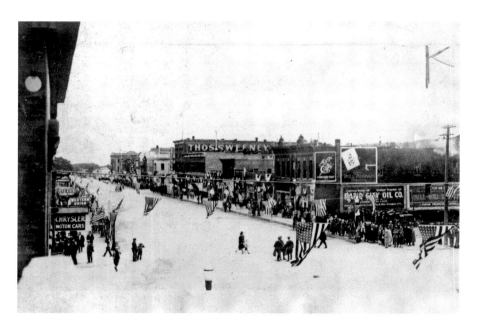

Rapid City's Main Street is decorated in anticipation of the arrival of the first couple. *Pat Roseland collection.*

engines grunted as they puttered up an elevation gain of about one thousand feet, over the twelve-mile gravel road that was so hurriedly improved during the previous two weeks.

Here, with the sinking sun bathing the scene in dramatic light, the Coolidges got their first breath of fresh mountain air, their first smell of the pine forest and their first taste of a summer of relative freedom and privacy, away from the heat, humidity, bugs and hubbub of the nation's capital.

"It was one of the most beautiful scenes that has ever unfolded itself to President Coolidge," wrote a correspondent for the *New York Times.* "Every turn of the road brought something different before the eyes of the vacationists. The air was cool, it was drizzling slightly as they left their train, but the sun broke through the clouds during the trip through the mountains, illuminating the lofty peaks.

"Cascades appeared along the roadway. The President looked with wonder upon the stone sentinels that seemed to guard his way."[58]

The caravan arrived at the State Game Lodge at 7:30 p.m. that evening. Soldiers from the Fort Meade detachment who were there to guard the president and the lodge for the summer stood at attention as the caravan pulled up.

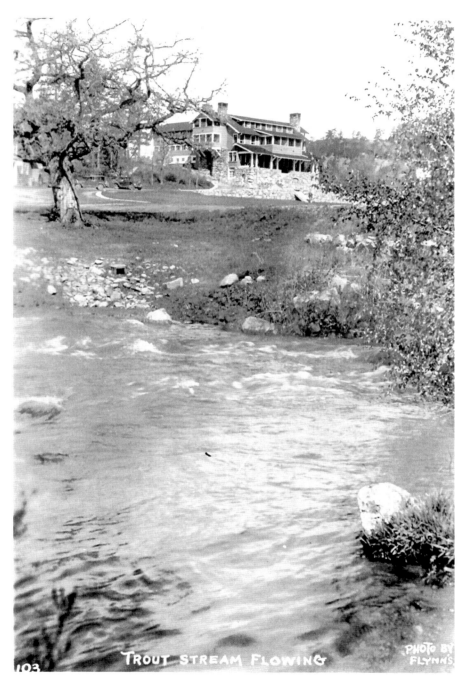

A stream runs past the State Game Lodge during the summer of 1927. *Photo by Flynn's, Pat Roseland collection.*

Soon the president was sitting by one of the lodge's massive stone fireplaces, reading some communications from Washington, D.C., that his staff had given him.

Later that week in Rapid City, he would tell reporters that he was pleased with his summertime home.

"I have a very fine location out at the State Game Lodge," he said. "I think most of you have been out there. It is just exactly what I like."[59]

While he'd been on a train from Monday night to Wednesday evening, his political rivals, including some within his own party, were preparing to pounce if he failed at his summer-long attempt to win the affection of farmers.

Republican supporters of Frank Lowden had issued a statement outlining the reasons to nominate him for president in 1928 over Coolidge. Their main argument was the president's apparent estrangement from farmers because of his veto of the McNary-Haugen farm relief bill. Lowden, as a former governor of Illinois, was well positioned to carry farming states, his supporters said, while Coolidge was doomed to lose them.

"Should the voice of the voters of the great and productive Middle West—which if the nation is to continue prosperous must share equally with other sections of the nation in that prosperity—go unheeded in 1928, our party will assuredly reap the whirlwind and become the victim of its own blindness and stupidity," the Lowden faction said in a statement issued the day of the president's arrival in South Dakota.[60]

That and other challenges to his presidency might have been on Coolidge's mind as he relaxed that first evening in the State Game Lodge.

Or as the next day would show, he might have been conjuring images of feisty trout swimming in the cool mountain stream running past the lodge.

PART II

ADVENTURE

6

FISHERMAN-IN-CHIEF

*Those trout would fight and battle one another to see which could grab
the President's hook first.*
—South Dakota governor William Bulow[61]

After all the speculation about President Coolidge's political motivation for
his summer vacation, he showed that another motivation was his simple
desire to go fishing.[62]

He woke up between 6:00 and 6:30 a.m. on his first morning in the Black
Hills and immediately went out to dip a line in the stream running past the
State Game Lodge, which was then called Squaw Creek but was renamed
Grace Coolidge Creek about two weeks later by the state legislature.[63]

Not surprisingly, the president caught nothing during that brief first
effort. Coolidge enjoyed fishing, but he depended largely on others to
engineer his success.

Edmund Starling, the Secret Service man who was nearly always at the
president's side, took credit for introducing the president to fishing during
the previous summer when the Coolidges vacationed in the Adirondacks of
New York.[64] The president took to the sport immediately. He was aided by
personal attendants who handled the gear, the transportation, the choosing
of the fishing spot and, reportedly at first, even the baiting of the hook
and removal of the hook from the fish's mouth.[65] Starling thought it was
important for the president to have a stress-relieving hobby, so the Secret
Service man carefully cultivated and choreographed the president's interest
in angling thereafter.

President Coolidge, wearing a business suit and straw hat, fishes from the bank of a stream in Custer State Park. *A.B. Kellogg Scrapbook, Rapid City Public Library.*

Starling was an avid fisherman himself and may have had selfish reasons for encouraging the president to pick the Black Hills for a vacation. Back in May, when Starling went west to visit all the potential vacation spots in various states, the *Rapid City Journal* reported that the "piece de resistance" of his visit to the Black Hills was a luncheon where he dined on fresh, locally caught trout and "remarked that they were the finest he had ever eaten."[66]

It's unclear where Starling was on that first morning of the president's Black Hills vacation when the president's brief attempt at fishing ended quickly in failure. By 7:00 a.m., the president was back at the lodge for breakfast with Mrs. Coolidge, where they ate trout that had been presented to them upon their arrival the previous evening.

The taste of the fish must have strengthened the president's resolve to catch some of his own. Just before 8:00 a.m., he reemerged from the lodge, and this time, the chief executive had hip-waders over the pants of his gray business suit.

Mrs. Coolidge came outside, too, and she and the president walked to a nearby cottage to visit one of their collie dogs, Prudence Prim, who had gotten sick during the night. The dog would die of distemper about a month later despite the efforts of veterinarians at Fort Meade.

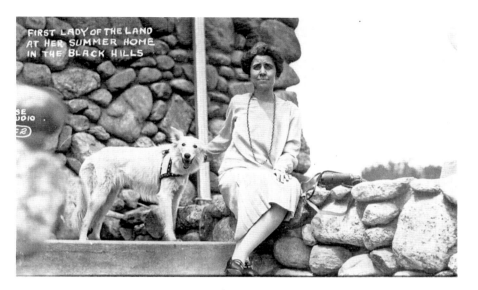

First Lady Grace Coolidge with one of her dogs, Prudence Prim, at the State Game Lodge. *Rise Photo, Pat Roseland collection.*

The dog meant so much to President Coolidge that when he published his autobiography two years later, the "I do not choose" announcement and the dog's death were the only aspects of the South Dakota vacation that received a mention.

"We lost her in the Black Hills," the president wrote of Prudence Prim. "She lies out there in the shadow of Bear Butte where the Indians told me the Great Spirit came to commune with his children."[67]

That sadness was still far off, though, during the Coolidges' first morning in the Black Hills. After visiting Prudence Prim, they lingered awhile on the grounds of the State Game Lodge.

"Apparently much pleased with their new wilderness home, Mr. and Mrs. Coolidge gazed at the pine clad hills which rise precipitously from their residence and stood for a moment in the warm sun which had risen to chase away the chill of a mountain night," the *New York Times* reported.[68]

Mrs. Coolidge told the news reporters and photographers—who were watching the couple's every move, as were some onlookers who were kept farther back on the road leading to the lodge—that the Black Hills reminded her of the president's boyhood home in rural Vermont. She raved about the previous night's sleeping weather.

"The air is so cool and toning," she said, according to one newspaper correspondent, "that one wakes up feeling stronger and greatly refreshed."[69]

The president was itching to get back to the stream, and by 8:00 a.m., he was off, this time with Starling and also with Cecil "C.C." Gideon, who managed the State Game Lodge. With no other guests at the lodge for the summer, Gideon traded his usual duties to become the president's personal fishing and sightseeing guide.

Starling and Gideon drove the president to a spot along the stream several miles from the lodge. There the president, making use of his waders, "plowed through the cold water with zest, having been told that the best holes could be reached only in that way."[70]

He caught a fish within two minutes.

"The bait had hardly dropped to the bottom until a trout made the reel sing," a newspaper correspondent reported.[71]

The fishing continued for about two hours, after which the president declared, "That's enough." Seven trout were caught, apparently five by Coolidge and two by Starling, although the president initially described all seven as his own.[72]

Back at the lodge around 11:00 a.m., the president leapt out of his car carrying a small wicker basket full of fish. He rushed over to his wife, who was sitting on the steps of the lodge, and showed off his catch as the news photographers snapped pictures.

The next day, during his first visit to his summertime office at Rapid City High School, he talked to reporters about the fishing excursion.

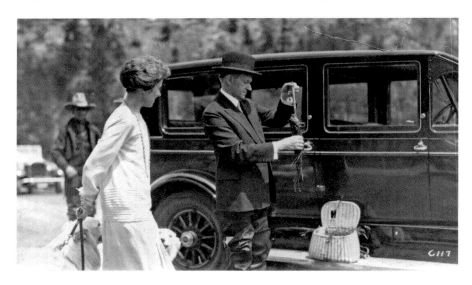

Grace Coolidge watches as President Coolidge pulls a fish out of a basket in Custer State Park. *A.B. Kellogg Scrapbook, Rapid City Public Library.*

"The trout that I caught yesterday were rainbow trout," he said. "I never happened to catch any of those before. They are a very good game fish to catch and very good fish for the table. I thought my first fishing trip in the hills was attended with very excellent luck."[73]

Actually, luck had little to do with it.

Later stories told about the pains taken to ensure that the president caught fish might be somewhat exaggerated, but they were told by two people who were in a position to know: Starling, of the Secret Service, and the state's then governor William Bulow.[74]

As Bulow told it, he and his wife were dining with the Coolidges at the Game Lodge a few days after the couple's arrival. One of the courses was trout caught by the president. Bulow later claimed that the rainbow trout on his own plate "had a very familiar look." As he sat there looking at the fish, he recalled being at the fish hatchery in Spearfish, in the northern Black Hills, where thousands of fish grew so fat and so tame that "they would swim right up to you and eat ground liver or ground horse meat out of your hand."

Bulow's mind raced back to May, when he and other state officials were making frantic preparations for the president's visit. According to Bulow, state officials knew Coolidge's lack of trout-fishing experience would spell trouble for his angling efforts in the Black Hills.

So, according to Bulow, the state's chief game and fish warden selected two deputy wardens "who could keep their mouths shut and who could see well on dark nights." They confiscated all the fish fifteen years and older out of the Spearfish hatchery ponds and took them to the creek near the State Game Lodge. Before releasing the fish, they stretched a section of wire netting across the creek under a bridge just east of the lodge, and another section under another bridge two miles downstream.

Those two miles of the creek were set aside as the president's private fishing grounds, and Bulow wryly described them as "the best trout fishing in all the world."

All of that knowledge flashed through Bulow's mind, he claimed, as he sat looking at the fish on his plate when he dined with the president at the State Game Lodge.

"The first bite I took," Bulow recalled, "I could plainly taste the ground liver and the ground horse meat upon which that trout had lived for years."

Bulow managed to choke down several bites, thanks partially to a numbing of his senses achieved with a few Prohibition-banned drinks of brandy that he'd secretly sipped earlier.

Twenty years later, with President Coolidge long dead, Bulow published his colorful recollections of the president's Black Hills fishing exploits in a magazine article. Starling wrote a similar but shorter account of the president's fishing adventures in an autobiography published the year before Bulow's piece.

Starling, like Bulow, claimed that steel-mesh nets had been stretched across the creek, but Starling claimed he placed the fish in the creek himself. He also mentioned the president's initial use of worms as bait instead of flies, which the president had admitted to reporters at the time and which had set off a minor national controversy among anglers, some of whom considered the use of worms for trout fishing unsportsmanlike.

After the publication of Bulow's 1947 article, Grace Coolidge corresponded with a *Rapid City Journal* newspaper executive about a possible return trip to South Dakota that never materialized. In one of her letters, she mentioned Bulow's article and said she had "many a chuckle over it."

"The big fish may have been 'planted,'" she wrote, "but I have the notion that the President had his suspicions and enjoyed seeing the Governor choke down some of his catch."[75]

The President and the Boy Preacher

Well, I did the best I could, but I'm glad it's all over.
—Rolf Lium, student pastor[76]

After that first day in the Black Hills, Coolidge established a routine of traveling the thirty-two miles to Rapid City on weekday mornings, conducting business and receiving visitors in his office at Rapid City High School and then returning to the State Game Lodge for lunch with Mrs. Coolidge and a nap. Afternoons were reserved for fishing and other forms of recreation or sightseeing.

Curious locals and tourists were allowed to drive and park along the road leading past the State Game Lodge, where they could watch from a distance if the Coolidges were on the front porch. The public also watched from the lawn of Rapid City High School as President Coolidge came and went. Throughout the summer, crowds followed him, but he was never far from the escape of his office, the lodge or the recesses of the Black Hills.

Many distinguished guests visited Coolidge at the lodge or high school, including General John Pershing, who led American forces in World War I; Herbert Hoover, who was then secretary of commerce and would soon be president; Leonard Wood, governor general of the Philippines and a former army major general; and a number of cabinet secretaries, senators and representatives.

The regular and important work of the country continued throughout the summer. Among other things, Coolidge met with a delegation of women seeking passage of an equal rights amendment to the Constitution, stayed

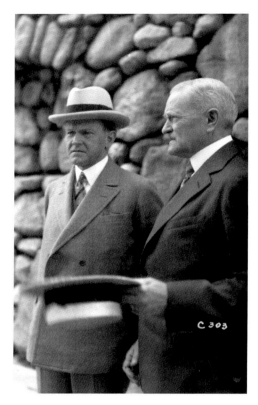

Left: Retired army general John Pershing, a hero of World War I, visits with President Coolidge at the State Game Lodge. *Rise Photo, A.B. Kellogg Scrapbook, Rapid City Public Library.*

Below: Retired army general Leonard Wood, who was governor general of the Philippines at the time of this photograph, with President Coolidge at the State Game Lodge. *Rise Photo, A.B. Kellogg Scrapbook, Rapid City Public Library.*

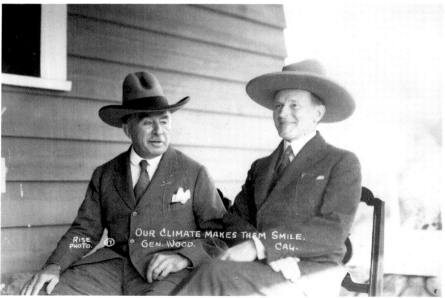

abreast of negotiations at a naval arms limitation conference in Switzerland and rejected calls to intervene in the Massachusetts execution of the infamous anarchist-murderer convicts known as Sacco and Vanzetti.

Besides conducting the public's business and enjoying recreation and relaxation, another summertime routine established by the Coolidges was attendance at Sunday worship services. They chose a tiny, white, clapboard Congregational church in Hermosa, which was the closest church to the State Game Lodge and was reminiscent of the small church that President Coolidge attended as a boy in rural Plymouth Notch, Vermont.

The Hermosa church lacked a full-time pastor, which was not unusual for remote villages on the recently settled plains of western South Dakota in the 1920s. Some churches went without a pastor over the winter and then received a missionary pastor for the summer.

Hermosa, on the eastern edge of the Black Hills about twelve miles northeast of the State Game Lodge and twenty miles south of Rapid City, was an especially remote outpost supported by ranchers from the surrounding plains and inhabited by about one hundred residents. For the summer of 1927, the town's Congregational church was sent a twenty-year-old college student to serve as its pastor. His first Sunday service with the church also happened to be the first one attended by the Coolidges on June 19, 1927.[77]

The student was Rolf Lium, a tall and athletically built young man with handsome, blond-and-blue-eyed Norwegian features and a jaw that looked as solid as Black Hills granite. Though he was the son of a Lutheran pastor who had died fifteen years earlier, Lium was not planning to enter the ministry himself. Instead, he was majoring in chemistry at Carleton College in Northfield, Minnesota, and hoping to go on to medical school.

Lium's supposedly naïve surprise at the president's choosing of the Hermosa church made for a good story in the nation's newspapers, but the ambitious young man must have had some inkling that the president, himself a Congregationalist, might attend the only Congregational church within fifteen miles of the Summer White House. Lium's anticipation of that possibility might explain why he declined an opportunity to earn $150 per month driving a milk truck for the summer in Yellowstone National Park and instead accepted the $50 per month, plus free room and board, that he earned while serving the church in Hermosa.

Whatever Lium thought he was getting into, it must have paled in comparison to the reality of delivering his first sermon while the president and First Lady sat among the congregants, a standing room–only crowd looked on from the back of the church, newspaper reporters scribbled

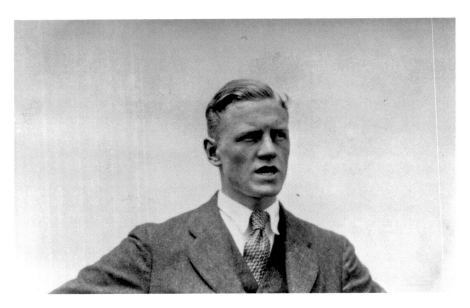

Rolf Lium, the student pastor who preached to the Coolidges during the summer of 1927. *Pat Roseland collection.*

notes for stories that would be distributed nationwide and a horde of press photographers waited outside with giant cameras on tripods.

The president's staff had announced several days earlier that the president and First Lady would be in attendance at the service, and people had flocked from miles around for a chance to worship with the Coolidges. An hour before the service's 11:00 a.m. start time, automobiles began chugging into Hermosa and filling the dusty streets like a procession of ants.

Outside the boxlike church with its humble steeple, Lium sat on a railing with his long legs dangling, his hands clasped and his skin probably wet with sweat under his dark suit. "Great flocks of fleecy clouds" passed overhead and "tempered an otherwise hot sun," a reporter wrote, while the smell of Black Hills pines wafted in from the west and the plains sloped away to the east.[78]

Depending on the source, Lium was either anxiously determined or a nervous wreck. A *New York Times* correspondent quoted the young man as saying, "They tell me to be natural. I'll just try and do it."[79] Another reporter either remembered the comment differently or caught Lium in a darker mood and quoted him as saying, "Everybody tells me to be natural but try and be it."[80]

As 11:00 a.m. drew near, and with the president and First Lady having not yet arrived, Lium went inside the packed church and took his place on the small platform at the front alongside the Reverend George Williams, head of

Congregational Missions for South Dakota. Williams was apparently there for moral support or to make sure the young student didn't embarrass the denomination—or both.

The Coolidges finally arrived five minutes before eleven o'clock. The packed congregation stood as the first couple followed an usher up the green carpet that covered the church's center aisle. The president and First Lady were seated in the third row, in chairs with red, white and blue ribbons tied to the chair backs. The church did not have pews.

A member of the church later recalled that the Coolidges always kept at least one empty seat between them to honor the memory of their younger son, also named Calvin, who had died three years earlier at the age of sixteen from blood poisoning caused by an infected blister suffered while playing tennis on the White House grounds.[81]

As the Coolidges sat down and looked up at the nervous twenty-year-old who took his place behind the pulpit, they might have thought of their deceased son, who would have been nineteen that summer, and their other son, John, a college student who was the same age as Lium. John would come to visit the Coolidges later that summer in the Black Hills.

The Coolidges stuck out in the crowd, not only because of their recognizable faces but also because they were surrounded by ranch families with tanned, weather-beaten skin. But the congregants were dressed nearly

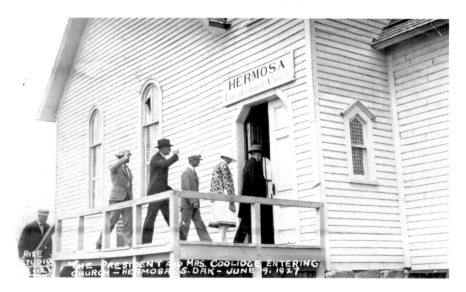

The president enters a Sunday service at the Hermosa Congregational Church. *Rise Photo, Pat Roseland collection.*

as impeccably as the Coolidges, with the men in suits and the women in dresses and fancy hats. The only people who looked out of place were the press photographers outside.

"There was not a single touch of the bizarre West about the service except that furnished by the New York cameramen," a *New York Times* correspondent reported, "who had donned ten-gallon hats and reveled in their adornment."[82]

That same correspondent counted 219 people wedged inside the church, which was built to hold no more than 150, according to the observation of another reporter. A folding door that separated the main sanctuary from a back area used for Sunday school had been opened, and every available place to sit or stand was filled. The church had been meticulously cleaned and decorated with prairie flowers in glass vases.

With the Coolidges settled in their seats, Lium felt the weight of the entire congregation's attention fall on his slender shoulders. His height, at least six feet or a little taller, lent him a commanding appearance to offset his nerves. With the extra inches from the platform on which the pulpit stood, he towered nearly seven feet over the assembled crowd.

Lium launched into the service, following an order he had scribbled onto a piece of paper that he kept under the Bible on the lectern. One chronicler of the scene recalled a hush when the first hymn began that continued until Mrs. Coolidge's enthusiastic singing inspired others to join in. The president stayed silent.

Lium had memorized his sermon, but he stammered at least once and had to consult his notes. The part of the ten-minute sermon most remembered by reporters, and probably most appreciated by the vacationing president, was Lium's assertion that "men with great tasks before them," like Moses and Jesus, "must withdraw to themselves in order to marshal their forces."[83]

When the offering was taken, the Coolidges reportedly gave $5.00 each, contributing to what was then the church's highest-ever collection of $47.49. In inflation-adjusted 2017 values, the Coolidges' combined gift of $10.00 would equate to nearly $140.00, and the total collection would be worth nearly $650.00.

The Coolidges were not mentioned until the very end of the service, when Williams, the denominational official who sat with Lium at the front of the church, asked everyone to remain seated for the departure of the honored guests.

The Coolidges stood, walked into the aisle and turned toward the pulpit, indicating a desire to speak with Lium. He stepped down and received a handshake, smiles and congratulations from the first couple. The president

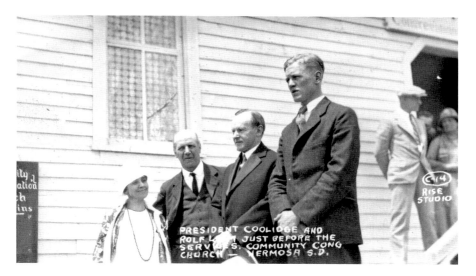

Mrs. Coolidge, an unidentified man and the president stand with Rolf Lium (*right*) outside the Hermosa Congregational Church. *Rise Studio, A.B. Kellogg Scrapbook, Rapid City Public Library.*

mentioned that the man who'd formally nominated him for president at the 1924 Republican National Convention was an alumnus of Carleton College, where Lium attended.

Outside, press photographers and movie-reel videographers eagerly made images of the Coolidges and the young preacher. As the rest of the congregation filtered outside, a relieved Lium became the recipient of congratulatory back slaps and handshakes.

"I have a girl back home," he said to one young girl who expressed appreciation for his sermon. "When she and my mother sees me in the movies, say, won't they just drop dead?"[84]

Actually, Lium's mother, Louise, was perturbed by all the attention her son received from the press. She told a reporter who tracked her down at her Northfield, Minnesota home the next day that she had discouraged her son's decision to serve as a student pastor because she "didn't think he would prove equal to it" and because he was studying to become a physician rather than a minister.

"I think they're making too much over my boy's preaching to the President," she said.[85]

Mrs. Lium's dismay about her son's instant celebrity status was not shared by newspaper reporters and readers, most of whom fell head-over-heels for the handsome young "boy preacher," as many reporters labeled him.

Nearly every reporter who covered Lium's first sermon paid him the era's ultimate compliment by describing him as similar in appearance, manner and achievement to Charles Lindbergh, who had spent part of his childhood in Minnesota like Lium.

The national Congregational Church capitalized on the pair's celebrity status by publishing a booklet titled "Lindbergh and Lium," in which Lium's adventure in South Dakota was compared to Lindbergh's over the Atlantic. The booklet said the two men's "clean young manhood has caught the imagination of the multitude."[86]

The Coolidges returned on subsequent Sundays and became regular guests at the Hermosa Congregational Church throughout the summer. All of their visits were memorable, but one, on August 7, became especially so when the president's Secret Service detail, cognizant of recent bombings by radical Sacco and Vanzetti supporters on the East Coast and elsewhere, searched the Hermosa church for explosive devices before allowing anyone to enter.[87]

Near the end of the summer, in the days before the Coolidges returned to Washington, D.C., they hosted a picnic for the entire Hermosa congregation at the State Game Lodge.

Some ninety years onward, the church, now called the Hermosa United Church of Christ, still stands and is fronted by a large sign proclaiming it to be the site where President Calvin Coolidge attended services in 1927. Inside, photos from that historic summer hang in the foyer, and an encased quilt with a square made by Grace Coolidge, complete with her name embroidered on the square, hangs in the back of the sanctuary.

As for Lium, his star continued to burn brightly for a while, and opportunities came his way. One of those came from the Redpath Bureau, which sent Lium on a traveling lecture series in 1928–29 after his graduation from Carleton College. The bureau's promotional booklet quoted praise of Lium from an unidentified writer.

"I venture to say," read the quote, "that it took as much courage and of as high an order for that lad of twenty to stand before the President and expound his beliefs as it did for Lindbergh to 'hop off' for his flight across the ocean."[88]

Lium's fame eventually faded, but by then, he had parlayed it into an acceptance at the Harvard Medical School. He eventually graduated, became a surgeon, settled in New Hampshire and served a stint as president of the Harvard Medical Alumni Association. He died in 1986.[89]

For the first couple, the wholesome glow from the press coverage of their church attendance soon burned away under the harsh spotlight that was cast on an awkward episode involving them and the Secret Service.

8

FIASCO IN THE FOREST

This disgraceful act of the President caused a mental scar on Mrs. Coolidge,
which, I believe, was never erased.
—Joel T. Boone, White House physician[90]

Calvin and Grace Coolidge were a clear case of opposites attracting. Her ready smile, easy charm and trendsetting style supplied the nation with a warm and inviting contrast to the aloof president.

And he knew the important role she played in dulling his sharp edges.

"For almost a quarter of a century she has borne with my infirmities, and I have rejoiced in her graces," he wrote in his autobiography.[91]

Being cognizant of those infirmities did little to aid the president in controlling them. They simmered below the surface of his stoic public façade until something heated them up and they boiled over in private. The stress of the presidency seemed to make him more irascible than ever, as did the tremendous grief caused by the death of the Coolidges' younger son, Calvin, in 1924.

The marriage that the Coolidges brought to the Black Hills was impaired by those stresses and by the president's resulting outbursts.[92]

"The supposition that he was always phlegmatic and self-controlled is shattered by many anecdotes proving that he was capable of explosions almost volcanic in their fury," wrote one biographer, adding, "Little things like the misplacement of an overcoat enraged him even more than real causes for anger."[93]

It was those closest to the president who suffered the worst burns from his eruptions, and Grace bore the scars of some of those episodes. One occurred during the first month of their Black Hills vacation.

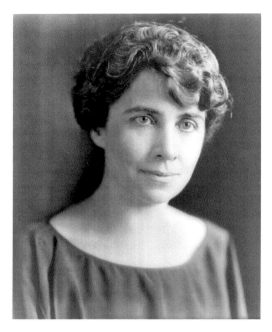

A 1924 portrait of Grace Coolidge. *Harris & Ewing Collection, Library of Congress.*

It happened on Monday, June 27, 1927. The president had taken his typical morning automobile ride to Rapid City and conducted some business in his office at the Rapid City High School. He returned to the State Game Lodge in Custer State Park at about 1:00 p.m., expecting to find Grace ready for the lunch they shared daily at that time. But she was not there.

That morning, Grace went out for her first lengthy Black Hills hike. She had long been a committed walker, sometimes covering eight miles on her daily strolls in Washington, D.C.

Her regular walking companion was a tall and slim Secret Service man named Jim Haley, who drew the assignment partly because his long stride helped him keep up with the First Lady's brisk pace. The two were a common and welcome sight around Washington, D.C., where Haley sometimes waited as Grace interrupted her walks to window-shop or meander through a store.

On that morning of their fateful Black Hills hike, the two set out from the State Game Lodge around nine o'clock. The Black Hills were in the midst of a minor heat wave, and by 10:00 a.m., the temperature was eighty-five degrees.[94]

When the president arrived at the lodge for lunch and Grace was gone, he probably felt annoyed at first and then might have grown concerned. He knew she had been gone four hours already, and he might have been worried about her condition in the heat. He had a fear of snakes, too, and might have suspected she suffered a rattlesnake bite.

With reporters aware of the situation and watching the obviously anxious president, he stationed himself on the front porch of the lodge. A search party set out on foot while he waited.

At 2:15 p.m., more than an hour after the president's arrival and more than five hours since the morning hike began, Grace and Haley finally

arrived back at the lodge. Grace, wearing a skirt, white silk shirt, sweater and hiking boots, got a glass of water and then joined her husband on the front porch, in view of some reporters.

The president paced as Grace explained how she and Haley had gotten lost during the hike. Soon, the Coolidges went inside. The president might have flashed some anger behind closed doors, according to White House physician Joel Boone's recollections of his later conversations with Grace.

"I believe the President became so irritated that Mrs. Coolidge was not right there at the lodge when he returned from his office that particular day that as he waited he boiled up and boiled up until he exploded," Boone wrote.[95]

Newspapers published unflattering stories about the incident. "President Gets Anxious as Lunch Time Comes and Wife Is Away," said one of the headlines in the *Rapid City Journal*. A *New York Times* headline was similarly worded: "Fifteen-Mile Walk in Hills Causes President Anxiety as He Waits an Hour."

The next day was a Tuesday, and the president met reporters at his Rapid City office for one of his regularly scheduled press conferences.

The gatherings were nothing like the modern, televised variety. Questions were written and submitted in advance, and Coolidge answered only the ones he chose and rarely allowed off-the-cuff queries. He insisted that reporters avoid quoting him directly and that they attribute paraphrased statements not to him, but to "the White House spokesman." The reporters typically obeyed.[96]

On this day, things were different. Coolidge was smarting from the coverage of the hiking incident. He lectured the reporters, choosing not to address the situation directly and instead concealing his irritation behind a false front of friendly advice about story topics.

"There are a great many things to write about here in the Black Hills, and I am going to make this suggestion to you for what it may be worth," he said to the press corps. "We shall be here for some weeks, and I think you will find that at the end of your stay here that your work will be more satisfactory if you take up some particular thing and write a very good story about it, and at a later time pass on to something else, rather than try to include almost everything in one story."[97]

Some of the reporters fell in line, but others refused to be manipulated. The *New York Times* published a news story about the president's comments under a mocking headline: "President Suggests Methods to Reporters."

"The President's thought is that they should let him alone and devote themselves to the scenic beauties of the Black Hills," read the story, in part.

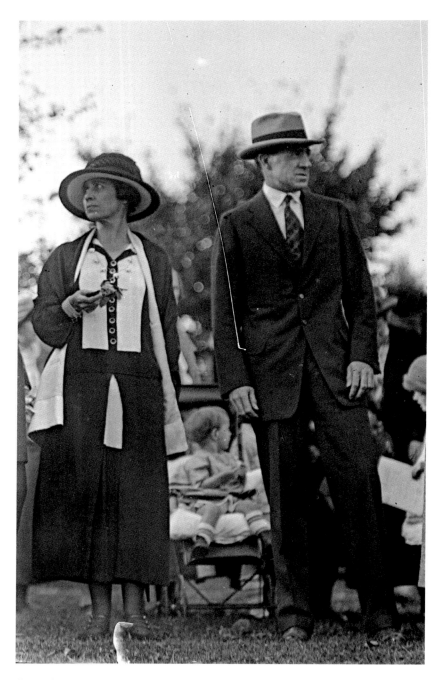

Grace Coolidge and Secret Service man Jim Haley in 1924. *Harris & Ewing Collection, Library of Congress.*

The story went on to quote a sarcastically worded question that a reporter had posed at the press conference: "Would you kindly give the daily assignment?" the reporter had asked the president.

"But the President," reported the *Times*, "backed water."[98]

That was enough to put a smudge on the president's shiny public image, but he didn't stop there. Two days after the hiking incident, he reassigned the offending Secret Service man, Jim Haley, back to Washington, D.C. That decision was reported in the newspapers, as was Coolidge's assertion that the move was a promotion, which did not fool anyone.[99] Later, Haley privately alleged that somebody opened a letter he sent to his wife following his dismissal from the First Lady's detail.[100]

There was no allegation of impropriety between Haley, who was happily married, and the First Lady. But the president's actions appeared to some observers like those of a jealous husband. His actions might have been motivated by concern for Grace and anger at Haley for getting lost, but the incident might also have drawn out some latent pangs of jealousy, caused by the amount of time Grace spent at Haley's side and by her enjoyment of Haley's company.

After the summer was over, Grace said as much to the physician Boone.

"She spoke frankly to me that day of Haley's dismissal at Rapid City by the President," Boone wrote, "saying that it was quite natural for her husband to dislike seeing and being aware that she was so much by force of circumstances required to be in another man's company."[101]

Grace cut back on her walks because she did not enjoy walking with the new Secret Service man assigned to her, she told Boone. The physician wrote that the Haley incident, even months later, seemed to have taken "some of her spontaneous gaiety away from her."[102]

Back in South Dakota, support for Grace came swiftly from the only woman in the state legislature, Mary Kotrba. On the day after the hiking incident, Kotrba introduced legislation to change the name of the stream that ran past the State Game Lodge from Squaw Creek to Grace Coolidge Creek.

"South Dakota is not more honored by the temporary residence of the President than by that of his talented, cultured and attractive wife," the resolution said in part, "who has already so firmly established herself in the affections of our people."[103]

Before the week was out, the legislation was adopted.

Later, after the Coolidges left the Black Hills, Grace fired the decisive shots in the marital duel. Displaying her capacity for independence and her skill at making amends for her sometimes tactless husband, she praised Haley in a

letter to the head of the Secret Service.[104] She was also the first customer in the door when Haley's wife opened a café in Washington, D.C.

"Mrs. Coolidge stayed half an hour," a reporter wrote. "Mrs. Haley valued her friendship too highly to ballyhoo the fact, but the word got around and business has been very good indeed."[105]

9

CRASH COURSE IN AIRMAIL

The weather there on the edge of the vast plains and under the shadow
of the Rockies was always a very live question.
—Army air corps first lieutenant C.E. O'Connor[106]

For President Coolidge, the fishing in the Black Hills was a treat, the relaxation and privacy were invigorating and the opportunity to conduct a goodwill campaign among westerners was welcome. But he acknowledged that none of it would have been possible without the ability to stay in meaningful communication with Washington and the rest of the world via airmail.

Government pilots had begun flying transcontinental airmail routes earlier in the decade. In 1925, Congress passed and Coolidge signed legislation directing the Postal Service to contract with commercial carriers for expanded routes. By the end of 1927, a robust network of airmail flights was being operated exclusively by commercial carriers.

It was an exciting and dangerous time in aviation. Charles Lindbergh made the first transatlantic flight in May 1927, several weeks before the Coolidges departed for the Black Hills. Lindbergh's feat electrified the nation and inspired an unprecedented wave of hero worship and emulation among the American public. All that summer of 1927, Lindbergh was fêted across the country while pilots eager to match and top his achievement took off on "hops" across oceans and landmasses, some of them crashing, disappearing or dying in the process.

It was predicted at first that airmail service would be unavailable to Coolidge in the Black Hills because Rapid City was off the established

The airmail terminal in North Platte, Nebraska, circa 1924. *Curatorial Photographic Collection, National Postal Museum.*

transcontinental routes. But because of the president's insistence, a special military operation was launched to collect his incoming mail at the transcontinental airmail terminal in North Platte, Nebraska, and fly it northwest to Rapid City, a distance of about three hundred miles. The flight took an average of three hours, one way, to complete.

The duty fell to pilots and mechanics selected from the army air corps' Sixteenth Observation Squadron of Fort Riley, Kansas, and the Third Attack Group of Fort Crockett, Texas. The operation was organized by then major and future five-star general Henry H. "Hap" Arnold.[107]

The mail was flown by two-man flight crews consisting of a pilot and a mechanic, with the mechanic doubling as the guard of the mail. A crew would fly to Rapid City with the president's incoming mail early in the morning, then back to North Platte with his outgoing mail the following afternoon. A regular flight schedule, weather permitting, was kept up by rotating among four pilots and ten mechanics.[108] The aircraft fleet ranged from three to six, all biplanes with top speeds of no more than 140 miles per hour. The planes had open-air cockpits from which the heads of the pilot and mechanic poked out, their eyes protected by goggles and their heads covered by aviator caps with earflaps.

Coolidge wanted to receive his mail promptly each Tuesday and Thursday, at the least. Arnold was apprehensive about committing his pilots to such a consistent schedule given the unpredictability of weather on the Great Plains, so he quietly devised a way to keep his pilots safe and Coolidge happy. When the bundles of mail arrived at the Rapid City airfield to be hauled by truck to the State Game Lodge or to the presidential offices at Rapid City High School, some of the mail was held back. That way, even if weather or mechanical problems prevented the next scheduled flight, there would still be mail to deliver and the flow would appear to be uninterrupted.[109]

The wisdom of Arnold's plan was borne out by the experience of the pilots, who got a rude welcome to the region during the first week of their mission.

On Friday, June 17, giant thunderclouds darkened the skies over Rapid City and unleashed a hailstorm that seemed like an enemy air raid. An airmail pilot approaching the city had to fly at top speed to land before the worst of the storm hit. There on the airfield, hailstones fell so violently that they ripped holes in the wings of his plane and another plane that was parked on the airfield.[110]

The staff at the *Rapid City Journal* played down the storm, probably fearing negative national publicity about a violent weather event occurring just a week into the president's stay. The paper's next-day story described the storm as routine and said dismissively that the damage "melts today nearly as rapidly as the hail stones did yesterday under the rays of the hot June sun."[111]

The presidential correspondent for the *New York Times*, who was with the president at the Rapid City High School offices when the storm hit, viewed the violent weather through fresh eastern eyes and gave a far different account.

"President Coolidge, returning to the lodge from his offices today, escaped a terrific hail storm of cyclonic proportions which broke over the Black Hills, destroying crops, stripping trees of leaves and demolishing window panes," the correspondent wrote.[112]

The president and the First Lady had planned to eat lunch that day at a restaurant in Rapid City, but the president and his staff, seeing the sky darken and feeling a burst of wind and a sudden temperature drop of about ten degrees, abandoned that plan. The presidential limousine, with the president inside, raced to pick up the First Lady at the restaurant where she was waiting and then sped for the State Game Lodge.[113]

The hailstones, walnut-sized at first and decreasing in size during the half-hour duration of the storm, left some city streets "covered with a two-inch white coating that looked like so many moth balls" and had to be cleared

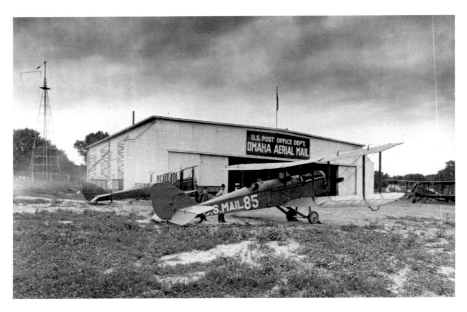

A 1927 image of an airmail plane, similar to the ones used to fly the president's mail, in front of a hangar on the Omaha, Nebraska airmail field. *U.S. Airmail Service collection, National Postal Museum.*

away with snow shovels. Windows were broken in the high school and in some other homes and buildings.[114]

The presidential limousine got away from the storm just in time and escaped its wrath. Lesser hail fell at the State Game Lodge.[115]

At the Rapid City airfield, the hail was described as being the size of golf balls and baseballs. One damaged plane was able to fly after extensive patching of its wings, but the other damaged plane had to be dismantled and shipped by rail for an overhaul. In the following days, construction began on a hangar to protect the airmail planes from future storms.[116]

For the pilots and mechanics of the presidential airmail service, the hailstorm was merely the first round of a summer-long fight against the unpredictable weather of the northern plains and Black Hills.

The pilots flew by sight and compass, avoiding the most desolate stretches of the Nebraska Sandhills and South Dakota Badlands and keeping sight of railways, highways and telephone and telegraph lines so they could be found quickly if they crashed or made an emergency landing.[117]

Morning fog over the river valleys between North Platte and Rapid City was a common hazard, and the pilots tried to fly over or below the fog for better visibility. When they dropped low, the fog remained so thick at times

that their plane brushed the tops of trees. Several times when the fog was particularly bad, pilots set their plane down in a pasture or field and waited for better conditions before continuing the flight.[118]

One such instance happened on June 30 and resulted in a reunion of World War I comrades. Pilot Arch McConnell landed his plane in a pasture twenty-two miles north of Alliance in northwestern Nebraska. To McConnell's surprise, he recognized the farmer who came out to check on him. It was G.W. Miller, who'd flown with McConnell during the war. Miller's plane had been shot down in the Alps and McConnell assumed him dead, but Miller had been taken to a hospital for a lengthy recuperation.

Their reunion was brief.

"The sky cleared and McConnell again took the air to deliver the President's mail, promising to see Miller soon again," said a report of the chance meeting.[119]

Not every fog-affected flight ended so happily. On August 25, with just two weeks left in the summer-long mission, airmail pilot James "Jimmy" Daniels found himself closed in by fog and tried to land in an alfalfa field near Bridgeport, Nebraska. His plane clipped the edge of a stand of trees at about 120 miles per hour and crashed into the ground.

When rescuers arrived, they found Daniels trapped and hanging upside-down from the cockpit, "his legs crushed and half an airplane on his back."

"For an hour he directed the hacking and sawing necessary to take him out of the wreck," wrote one of his fellow pilots.[120]

The plane's other occupant, mechanic Robert Barlow, had a broken leg and was bruised end to end but held firm to his role as guardian of the presidential mail. He "refused the two mail pouches to even the sheriff and insisted that there be no hypodermics for his shock until the nearest postmaster had properly signed for the executive pouches."[121]

The dedicated and heroic service of all the airmail pilots and mechanics is one of the most forgotten aspects of the Coolidges' summer in the Black Hills. That is perhaps because it was overshadowed by the two most famous airmail deliveries in the history of the region.

The first was on June 23, the day after the state legislature changed the name of a mountain in Custer State Park to Mount Coolidge. Gutzon Borglum, the sculptor who hoped to carve Mount Rushmore, hired local pilot Clyde Ice to fly over the State Game Lodge. Borglum reportedly went up with Ice and dropped a wreath onto the lawn of the lodge. Tied to the wreath were two moccasins, one bearing the words "Greeting from Mt. Rushmore to Mt. Coolidge." The stunt was part of an ultimately

Calvin Coolidge and Charles Lindbergh in November 1927. *Harris & Ewing Collection, Library of Congress.*

successful attempt to attract the president to the site of the proposed mountain carving, which had not yet begun, and to win his support for federal funding of the project.[122]

The second and best-remembered Black Hills airmail drop happened on September 2, when former airmail pilot and recent transatlantic hero Charles Lindbergh, on a whirlwind tour of the country to promote the growth of aviation, circled the State Game Lodge and Rapid City in his famed *Spirit of St. Louis* plane and dropped messages over each location.

A report in the *Rapid City Journal* said the drop over the State Game Lodge was seen to fall but was not immediately found. Ellen Agnes Riley, the Coolidges' head housekeeper, was at the lodge when it happened.

"We heard a plane overhead and I rushed out with the glasses and saw *The Spirit of St. Louis* with Lindbergh waving his hand from the cock-pit," she wrote. "I waved back and he circled over the flag-pole, dropped a note and was gone."[123]

The message that Lindbergh dropped over Rapid City was quickly scooped up by a local resident and taken to the *Journal* newspaper office, where it was proudly displayed in a window for passersby to read.[124]

The message was an unremarkable letter filled with boilerplate language expressing Lindbergh's regret at not having time to make a full stop and encouraging public support for continued airmail service and the construction of airports. The people of Rapid City were nonetheless dizzy with excitement about a momentous day that found President Coolidge working at Rapid City High School; First Lady Grace Coolidge shopping in Rapid City stores with their son John Coolidge, who'd come for a visit; and Charles Lindbergh flying overhead. The *Rapid City Journal* called it an "epochal morning."[125]

One week later, when the presidential party was about to leave Rapid City by train, President Coolidge underscored the importance of aviation to his vacation while delivering a speech to thousands of well-wishers.

"Had it not been for the development of invention, for the navigation of the air and the use of airplanes to transport mail," he said, "it would not have been possible for a President of the United States to spend any such extended length of time so far away from Washington."[126]

10

Cowboy Cal

He comes to capture the west. While he is here, the west should capture him.
—Omaha World-Herald[127]

Starting with the cowboys on horseback who escorted the Coolidges through Hermosa upon their arrival to the Black Hills and continuing throughout the summer, there was a decidedly western quality to the first couple's vacation that pierced the president's legendary reserve, thereby endearing him to the West and the West to him.

One uniquely western experience was a brief introduction to gold mining near a remote Black Hills cabin owned by former Nebraska governor Samuel McKelvie.[128]

The Coolidges started out from the State Game Lodge by automobile early on the morning of July 23 for the thirty-two-mile drive to Rapid City and then boarded a train for a thirty-four-mile ride to the tiny mining settlement of Mystic, where they climbed into one of several horse-drawn lumber wagons with a number of guests to cover the last couple of miles to the cabin over a logging road.

Rain from the previous night and an uphill slope made the going tough for the two-horse teams that pulled each wagon. The Coolidges and everyone else, except the drivers, climbed out of the wagons and walked awhile, and the president, dressed as usual in a suit, even helped push one of the wagons. Beads of sweat formed on his brow under a circular straw hat that shielded him from the hot sun.

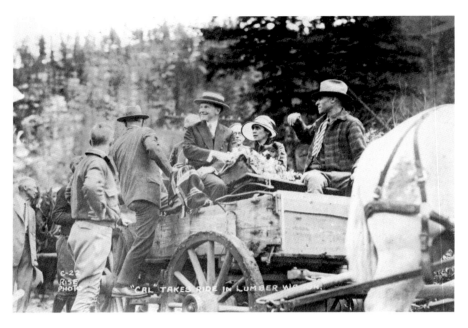

The president and Mrs. Coolidge ride in a lumber wagon en route to a Black Hills cabin owned by the former first couple of Nebraska Samuel and Martha McKelvie. *Rise Photo, A.B. Kellogg Scrapbook, Rapid City Public Library.*

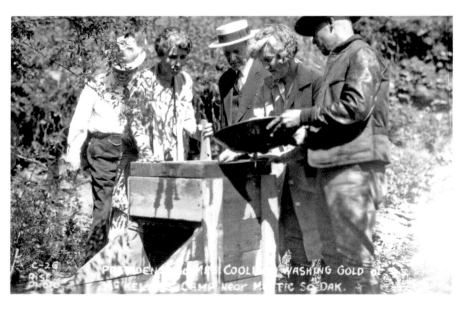

The Coolidges pan for gold with former governor of Nebraska Samuel McKelvie and his wife, Martha. *Rise Photo, Pat Roseland collection.*

At the cabin, the president fished unsuccessfully and then joined his wife to pan for gold. They swirled dirt that was hacked from a nearby mountainside with water from a cool and clear stream, and both were delighted to find small flecks of yellow settling to the bottom of their pans.

The trip doubled as a political reward for McKelvie, who was not only the former governor of Nebraska but was also the publisher of the *Nebraska Farmer*, an agricultural newspaper that supported Coolidge's veto of the McNary-Haugen farm relief bill.

COWBOY DRESS-UP

Many of the Coolidges' other western experiences were of the cowboy-and-Indian variety, starting with a particularly transformative episode on the occasion of the president's fifty-fifth birthday.

Coolidge was born on the Fourth of July, a fortunate coincidence for a politician. A festive and patriotic celebration was planned for him at the State Game Lodge, where numerous special guests and hundreds of onlookers crowded onto the lawn.[129]

When the Coolidges emerged from the lodge to greet their guests that day around one o'clock in the afternoon, the president was dressed in a blue suit, and Grace was wearing a white dress and fashionable hat. A cowboy band from Terry, Montana, played western music and cut a showy figure in shirts of bright red, green and purple, along with neckerchiefs and chaps of varying colors.

Out on the lawn, a troop of khaki-uniformed Boy Scouts from the Black Hills city of Custer presented the president with a gift horse named Kit. The bay mare had white markings on three of her lower legs and a white star on her forehead. The gift came complete with a saddle, bridle and saddle blanket, plus a cowboy outfit of gray chaps, riding boots, spurs, an elaborately tooled leather belt, a bright red silk western shirt and a purple neckerchief with depictions of running horses on it.

The cowboy band from Montana gave the president a pair of white chaps with "Cal" sewn in big letters on each leg.

Everyone had a picnic lunch, and the president enlisted Rapid City resident Mary Halley, who had brought him a sour cream chocolate cake, to help cut the large cakes made by the White House staff and the many smaller cakes sent by local well-wishers.

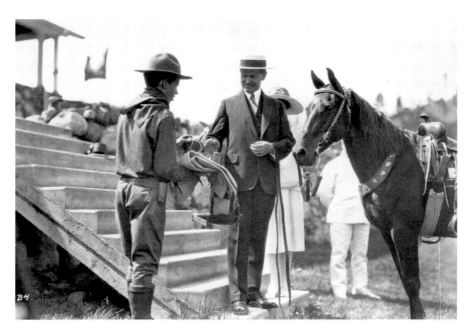

President Coolidge receives a horse and tack from a Boy Scout at the State Game Lodge. *Rise Photo, Pat Roseland collection.*

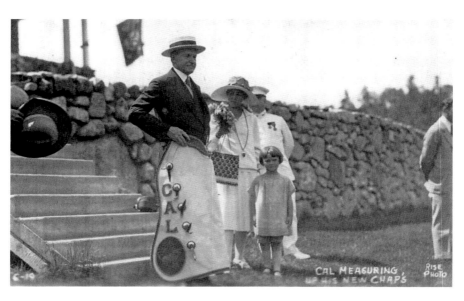

President Coolidge poses in the chaps he received as a birthday gift at the State Game Lodge. *Rise Photo, Pat Roseland collection.*

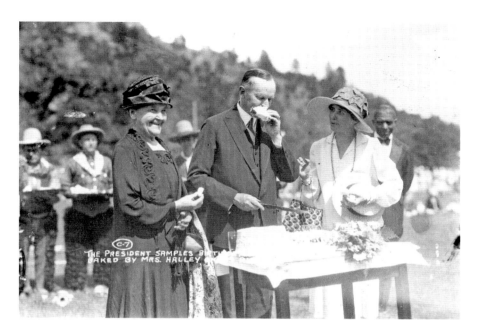

Mary Halley, of Rapid City, helps the Coolidges cut the birthday cakes presented to President Coolidge at the State Game Lodge for his fifty-fifth birthday on July 4, 1927. *Rise Photo, A.B. Kellogg Scrapbook, Rapid City Public Library.*

Then, recalled a reporter, "The celebration lagged for a minute."[130] The cowboy band began preparing to leave until someone shouted for them to wait while the president and Mrs. Coolidge retreated into the lodge for a few minutes.

The Coolidges soon reappeared on the porch, with the normally staid president now dressed in all of the cowboy regalia he'd received as gifts. On his head was a gaudy, ten-gallon felt cowboy hat he had been given earlier in the summer by residents of the city of Belle Fourche, who had invited him to their summer rodeo.

It wasn't the first time the president had worn the huge hat. To the delight of many South Dakotans, he'd donned it previously and had been shown wearing it in photographs published in newspapers across the country. By the Fourth of July, the hat was becoming a regular sight.

"The first day or two the president looked as though he felt a bit top-heavy, but yesterday the big lid seemed to be a part of him," the *Rapid City Journal* observed the day after the party.[131]

The members of the cowboy band reveled in the president's show of affection for western culture. They rowdily cheered his appearance and showered him with approving chants, including "Cal's our pal."[132]

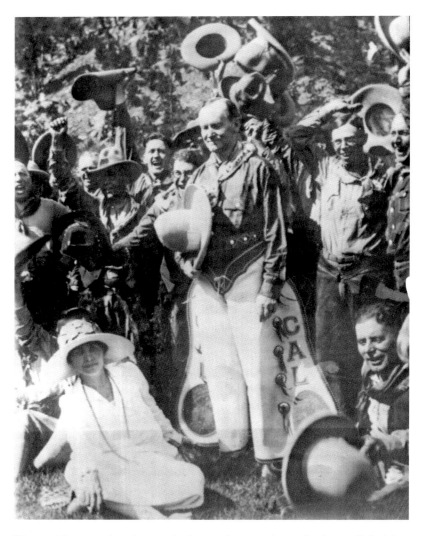

The president, wearing chaps and other cowboy gear he received as a gift for his fifty-fifth birthday, poses with the Cowboy Band of Terry, Montana, and the First Lady. *Pat Roseland collection.*

"Attaboy, cowboy!" someone had yelled as the president stepped onto the porch, weighted down by all his western accoutrements.[133]

A stunned *New York Times* correspondent looked on as the president, who'd been notably silent during the singing of hymns at the Hermosa church, joined "without restraint" into the singing of the cowboy band's songs and spoke with the cowboys in their own vernacular.[134] The only

MARY HALLEY'S PRESIDENTIAL SOUR CREAM CHOCOLATE CAKE RECIPE

After the *New York Times* reported on the sour cream chocolate cake given by Rapid City resident Mary Halley to President Calvin Coolidge on his birthday, July 4, 1927, at the State Game Lodge in South Dakota, the *Times* received more than one thousand letters asking for the recipe.

So, on July 24, 1927, the *Times* published the recipe as supplied by Halley (and based on 1920s-era kitchen technology):

CAKE

Butter two cake pans well, then flour them.

Put in a bowl: Seven eighths of a cup of granulated sugar, one full cup of rich sour cream, two eggs, one teaspoonful of vanilla.

Put in a flour sifter: One rounded cup of cake flour, one-half rounded teaspoonful of soda, one rounded teaspoonful of baking powder and a pinch of salt.

Sift the above into the sugar, cream, eggs, etc.

Mix and beat quickly until smooth, only a couple of minutes. Then put into pans.

Turn the gas on in the oven when you start preparing the cake. Have all the materials around you. The cake will bake in fifteen minutes in a quick oven.

FROSTING

Two cups of granulated sugar, one and one-half heaping tablespoonsful of cocoa, one-half cup of sweet or sour cream, one teaspoonful of vanilla, scant one-half cup of butter.

Put on stove. After it begins to bubble, allow it to cook for two minutes. Then place the pot in cold water and beat for two minutes. Then take out of water and beat until thick enough to spread on cake.

thing the president refused to do, to the chagrin of the Boy Scouts, was mount his new horse.

The magical afternoon seemed to be the moment when a love affair between Coolidge and the West was consummated and fears of an anti-Republican wave across the vast Great Plains began to fall away.

Under a story the following day about the birthday party that was headlined "Coolidge as Cowboy Wins West's Heart," the *New York Times* correspondent who was traveling with the president wrote that Coolidge had "suppressed his natural reserve," "showed a new personality" and "steeped himself in the atmosphere of the West."[135]

An admonition months earlier from the *Omaha World-Herald* about the West needing to win the president, instead of vice versa, now seemed heeded and fulfilled, although perhaps not in the way the newspaper's editorial board intended. While Coolidge gave his heart fully to the West, his mind remained unchanged about policy matters including his veto of the McNary-Haugen farm relief bill.

And as much as the West was winning over Coolidge, he was winning over many of its people. In addition to the gifts he received for his birthday, he received bundles full of birthday mail, including an estimated one hundred expressions of support for his reelection in 1928.

Some critical observers around the country cringed at what they considered the president's unpresidential behavior in South Dakota. Surely, many believed and said, it was political pandering of the worst kind. About a month later, after the president announced his decision not to seek reelection, others would look back and wonder if his suddenly uninhibited demeanor had been the result of a freeing decision to forgo another term.

THE FIRST COUPLE'S FIRST RODEO

The birthday celebration, memorable as it was, turned out to be only the beginning of a quirky romance between the president and the West. The romance continued to blossom the next day, when the Coolidges attended the Belle Fourche Roundup with a number of distinguished guests and members of the press and presidential staff.[136]

The three-day rodeo was a massive gathering of rodeo cowboys and cowgirls, western-themed entertainers, city-dwellers, tourists and ranchers

from throughout the expansive rangelands that sprawled away in all directions from the Black Hills. Belle Fourche, on the northeastern fringe of the Black Hills, was a cattle-trading and shipping capital and one of the most authentically western places the Coolidges visited during their vacation.

A crowd estimated at sixteen thousand by the *New York Times* and twenty thousand by the *Rapid City Journal* filled the rodeo grounds and arena bleachers that day, July 5. Like the hundreds at the Game Lodge the day before, the rodeo-goers at Belle Fourche were immediately enamored when they saw President Coolidge wearing the ten-gallon hat he'd been given weeks earlier by the rodeo's organizers. He'd abandoned his other western attire for a business suit.

It was the Coolidges' first rodeo, in the literal sense of the expression, and the noted animal lovers seemed alternately delighted, puzzled and horrified as they looked on from their ringside seats.

They looked away during the bulldogging competition, when cowboys on horseback rode up alongside a steer at full speed, dropped down onto the steer's neck and used its horns as a lever to wrestle the steer to the ground. An anti-rodeo organization had written the president a letter urging him not

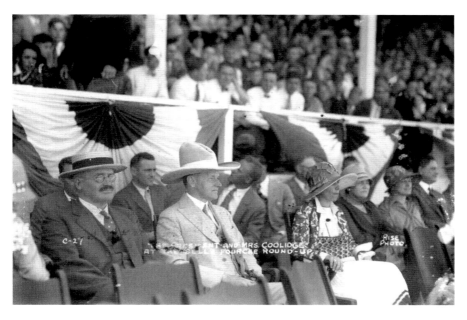

U.S. senator Peter Norbeck, of South Dakota (*left*), sits beside President Coolidge as Grace Coolidge sits nearby at the Belle Fourche Roundup. *Rise Photo, A.B. Kellogg Scrapbook, Rapid City Public Library.*

to attend the rodeo because of the "brutalities" against animals he would allegedly witness, and the letter proved prophetic when a steer's neck was broken during the bulldogging competition and the steer had to be shot.

Other rodeo events and entertainers seemed to meet with the Coolidges' approval. The president smoked cigars and bore an expression for much of the day that was described as a "quizzical smile."[137]

A stunt known as wild cow milking seemed to especially please the president, perhaps because the victims of the event's brutalities were the cowboys instead of the cattle. A number of cows—non-domesticated grazers raised for beef production rather than tame milking cows—were released into the rodeo ring with cowboys on horseback who attempted to be the first to lasso a cow and fill a jar with its milk.

South Dakota congressman William Williamson, who'd helped recruit the Coolidges to the state and knew Coolidge to be an extremely unexpressive man, was one of the dignitaries seated near the president and wrote about the chaotic scene years later.

"One of the cows right in front of the President's box heaved up her rear and sent the milker helter-skelter sprawling on the ground with the milk spattered over his face and neck," Williamson wrote. "The President roared with laughter in unison with the tremendous crowd. It was the first and last time I ever heard him laugh out loud."[138]

The President Goes Riding

The day after the rodeo, the president, apparently swept up by a current of western feeling, declared that he wished to ride the horse he'd been given two days earlier by the Boy Scouts from Custer.

There are differing accounts about what happened next. Newspaper stories of the day said Coolidge mounted Kit and rode with a delegation of other riders to a high point in the Black Hills, where he enjoyed an expansive view.[139]

Edmund Starling, the president's main Secret Service man, told a different story in his autobiography years later. Starling said he had ridden Kit himself and found her too unruly for the president. So, Starling captured a tamer horse named Mistletoe for the president from Custer State Park's stable and let Coolidge ride that steed the following day. Whatever really happened, the interest shown by the usually sedentary fifty-five-year-old

president in horseback riding was further proof of the degree to which the West had gotten into his veins.

Starling recalled those few days of cowboy dress-up, rodeo attendance and horseback riding as some of the best of Coolidge's life.

"If he had fallen asleep over a Buffalo Bill dime novel at the age of twelve and it had all come true, he could not have been more tickled," Starling wrote. "I had the impression all the time that he was living a boyhood that had been put off for forty years."[140]

One of Coolidge's closest aides, his private secretary, Edward T. Clark, made similar observations. The week after the birthday party and rodeo, Clark wrote a letter from Rapid City to Coolidge's primary political backer, Frank Stearns, the owner of a department store company in Boston. It's clear from the letter, written just three weeks prior to Coolidge's shocking announcement that he would not run for reelection, that Clark had little to no idea of the surprise to come and was expecting Coolidge to be a candidate in 1928. As such, Clark was anxious to know how Coolidge's western antics were being received back East.

Though Clark was as stunned and confused by Coolidge's suddenly uninhibited behavior as everyone else, he thought he was witnessing something other than political pandering.

"I have my own doubts as to it all, but I have made up my mind that the reason he has been able to put it over is because he is actually enjoying himself in these strange clothes and with a new kind of people," Clark wrote. "It seems to me that for the first time in his life he is actually playing."[141]

Things would turn serious, though, when Coolidge visited with a group of South Dakotans who'd been left far behind by the good times and rising fortunes of the Roaring Twenties. Those were the Sioux people, who'd been promised ownership of a broad swath of the northern plains, including the Black Hills, just fifty-nine years earlier in a treaty that was broken by the government Coolidge now led.

GREAT WHITE FATHER

You have come to the land of the Ogalallas, where dwell the descendants of those who offered the last resistance to the white man.
—document presented to President Coolidge, signed by the Reverend Amos Ross, Philip Deloria and Dallas Shaw[142]

In 1924, three years prior to his trip to South Dakota, President Coolidge signed the Indian Citizenship Act.

Some Native Americans had already earned U.S. citizenship through various means, including military service and marriage to whites, but the 1924 law extended citizenship to all of them. The law was partially motivated by national appreciation for the service of thousands of Native Americans in World War I.

Though the law signaled an attempt to solve what some whites of the time called the "Indian problem"—persistent poverty on many reservations, coupled with the refusal of some reservation dwellers to assimilate into white culture—relations between Native Americans and the federal government remained turbulent. That was especially true in South Dakota, where a legal fight between the Sioux and the federal government that would stretch across decades had recently begun.

The fight took the form of litigation. It was filed the year prior to the passage of the Indian Citizenship Act by the tribes that make up the Great Sioux Nation. They were seeking compensation for what they described as the illegal seizure of their land by the federal government.

The tribes claimed that the government violated the 1868 Treaty of Fort Laramie, a document that was intended to end hostilities between the

government and the Sioux by setting aside all of western South Dakota, including the Black Hills, and some additional tracts as the Great Sioux Reservation.

After a military expedition led by George Armstrong Custer discovered gold in the Black Hills in 1874, prospectors began a wave of illegal settlement that eventually caused the government to break up the reservation into smaller parts. Vast tracts of former reservation land were opened for white settlement.

So, while Coolidge's selection of a vacation site in the Black Hills was an honor to many white South Dakotans, it was an affront to some Sioux who believed the Black Hills were stolen from them by the government that Coolidge represented. That historical memory remained fresh for many people on the Pine Ridge Indian Reservation, southeast of the Black Hills, where there were still some old warriors who fought in the 1876 Battle of the Little Bighorn in what became Montana. Custer, along with nearly three hundred of his soldiers, was killed in that battle.

There were even more people living on Pine Ridge who could recall the 1890 Wounded Knee Massacre on their reservation. The army's slaughter of more than 150 people there crushed what little hope of Sioux resistance remained by that time and ended the so-called Indian Wars for good.

Since then, the government had pursued a policy of assimilation, meant to convert Native Americans from their traditional ways to full participation in white American culture. For the Sioux of South Dakota, that meant converting from bison-hunting to farming, educating their children in white boarding schools, speaking English and wearing Americanized clothing.

During the post-Coolidge Great Depression years, the government would abandon assimilation efforts for policies that emphasized Indian self-determination. But when Coolidge signed the Indian Citizenship Act in 1924 and when he traveled to South Dakota in 1927, his statements reflected a president who still hoped Native Americans could be assimilated.

With so many controversial contemporary issues and so much painful recent history weighing heavily on the minds of the Sioux, Coolidge's visits with them were fraught with complexity.

RAPID CITY INDIAN SCHOOL

The president eased into a series of Sioux encounters that summer. One of the first was his tour of the Rapid City Indian School on July 7, 1927, on which he was accompanied by the First Lady and others of the presidential party.

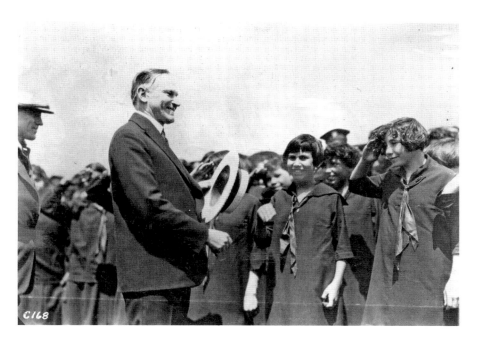

President Coolidge greets a group of Native American girls at the Rapid City Indian School. *A.B. Kellogg Scrapbook, Rapid City Public Library.*

A boy who boarded at the school presented the president with a stone-chiseled pipe and a beaded, buckskin carrying case, and a girl gave Mrs. Coolidge a pair of embroidered pillow cases.

"Mrs. Coolidge expressed considerable interest in the gift," a reporter noted, "and questioned the little girl about the work. Although one of the official escorts offered to carry the gift, Mrs. Coolidge clung to her present throughout the inspection."[143]

The Coolidges met Chauncey Yellow Robe, a teacher at the school and noted activist for the advancement of the Sioux people, and watched a traditional dance by Yellow Robe's daughter, Rosebud Yellow Robe. She would attract further interest throughout the summer from newspaper reporters, one of whom described her as "one of the most beautiful of the Indian maidens."[144] She soon parlayed that attention into a move to the East Coast, where she earned fame as a performer, storyteller, radio voice actor and children's book author. Her time working at the CBS Broadcast Center coincided with the tenure of Orson Welles, leading some to speculate that Welles borrowed her name for the legendary "Rosebud" sled in his 1941 film *Citizen Kane.*[145]

WILD HORSES

Several weeks after the Indian School tour, the Coolidges attended the Gold Discovery Pageant on July 27 in the Black Hills city of Custer.

The roads leading into the city that morning were packed with automobiles, including cars carrying members of the presidential party. The motorists parked their cars on a hillside overlooking a natural forest clearing, where hundreds of local and regional actors staged a "Winning of the West" pageant composed of numerous scenes.[146]

Some two hundred Native Americans participated in the pageant and apparently played their roles convincingly. During a scene in which some of them acted out an attack on a covered wagon pulled by a two-horse team, the spooked team broke loose of the wagon and galloped wildly toward the crowd with both cowboys and Indians racing after them.

Spectators scattered out of the way, and Mrs. Coolidge, seated near the chaotic scramble, put her hands in front of her face. The president jumped up, saw that the horses had run through the crowd without injuring anyone and reassured his wife.

"It seemed certain for a few moments," reported one newspaper correspondent, "that the horses would run down and kill or seriously injure many persons."[147]

PRESIDENT BECOMES "LEADING EAGLE"

The Coolidges' next notable encounter with the Sioux came on August 4 at the Days of '76 in Deadwood, a celebration of the Black Hills town's gold prospectors, miners and other early inhabitants. Buildings in the city were covered with log fronts to make them resemble their pioneer precursors, and men in the city grew beards in the style of early settlers.

"And the result was a reproduction that carried the present generation vividly back to the days of 1876," a newspaper correspondent reported, "when Deadwood was the greatest mining settlement of the United States."[148]

An estimated three to four hundred Native Americans, dressed in traditional attire, showed up at the celebration to honor the president. Chauncey Yellow Robe, who'd worn a business suit while greeting the Coolidges the previous month at the Rapid City Indian School, now appeared in a long-sleeved, buckskin shirt, buckskin pants and a feathered

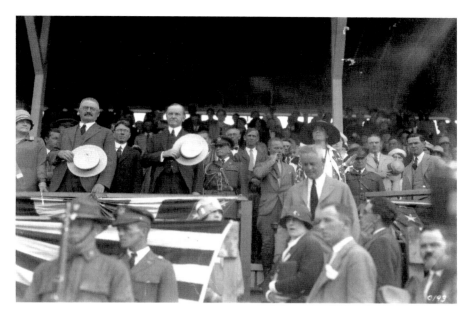

Senator Peter Norbeck stands next to President Calvin Coolidge while First Lady Grace Coolidge stands nearby (in hat) at the Days of '76 celebration in Deadwood. *A.B. Kellogg Scrapbook, Rapid City Public Library.*

headdress. Standing in front of the business-suited president with the First Lady looking on and with thousands of spectators watching from a nearby grandstand, Yellow Robe and other Indian dignitaries adopted President Coolidge into the Sioux Nation.

Rosebud Yellow Robe placed on the head of the president a war-bonnet headdress consisting of 180 large eagle feathers, which draped down his neck and backside all the way to the ground.

Coolidge was given an Indian name, which newspaper reporters spelled phonetically in various ways, including "Wamblee-Tokaha." The name reportedly translated to "Leading Eagle" in English.[149]

Henry Standing Bear, a fellow activist with Chauncey Yellow Robe for the advancement of the Sioux people, stood before Coolidge in traditional dress and face paint and gave a speech in the Lakota Sioux dialect.

"Our fathers and our chiefs, Sitting Bull, Spotted Tail and Red Cloud, may have made mistakes, but their hearts were brave and strong, their purposes were honest and noble," Standing Bear said, according to an interpreter. "They have long gone to their Happy Hunting Ground, and we call upon you, as our new High Chief, to take up their leadership and

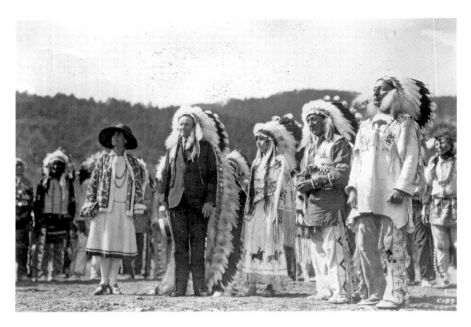

Grace Coolidge stands next to her husband, President Calvin Coolidge, who wears an eagle feather bonnet as he is adopted into the Sioux Nation. Next to the president (*from left*) are Rosebud Yellow Robe, Henry Standing Bear and Chauncey Yellow Robe. *A.B. Kellogg Scrapbook, Rapid City Public Library.*

to fulfill the same duty call from which they never did shrink, a duty to protect and help the weak."[150]

Years later, Standing Bear would recruit sculptor Korczak Ziolkowski to begin carving a colossal likeness of legendary Sioux leader Crazy Horse into a mountain near Custer. The still unfinished carving is now known as Crazy Horse Memorial.

The adoption of Coolidge into the Sioux Nation by a select few was not met with universal approval among Sioux people. Weeks later, the *Rapid City Journal* reported that there were "rumors of controversy among the Indians of the Sioux tribe" because of the adoption, which prompted Chauncey Yellow Robe to issue a lengthy statement in his own defense. He had consulted with a number of "other chiefs," he said, and "90 per cent of the Sioux people heartily endorsed the adoption."[151]

Land Claim Pressed at Pine Ridge

The climactic meeting between the president and the Sioux came on August 17, when the presidential party traveled by train and then automobile some 165 total miles to the home of the Oglala Sioux Tribe, the remote Pine Ridge Indian Reservation southeast of the Black Hills.

Amid a varied landscape of dusty badlands and rolling grasslands, the Coolidges encountered a throng of traditionally dressed Native people reaching an estimated ten thousand in number.

Here were some people who seemed to be living in a time and place apart from the rest of the nation, untouched by modernity.

"There has been much talk of the western atmosphere here and the spirit of the pioneers that has touched President Coolidge on his vacation visit in the West," wrote South Dakota columnist Walter Travis, "but opportunity has been his today to come as near the life of the old Indian days as he may come....The Pine Ridge country has many an Indian who can kill with a bow and arrow, and many a squaw who can light fire with a flint."[152]

At a tribal fairgrounds, the presidential party was treated to a parade depicting the changes and growing diversity in Sioux life: some participants wore colorfully traditional ensembles of headdresses, buckskins and moccasins; some wore World War I military uniforms; and some displayed their government-provided farm implements.

There had been an Episcopal missionary convocation a few days earlier that attracted Sioux leaders from other reservations to Pine Ridge, and many stayed for the presidential visit. At the parade grandstand, six Sioux leaders approached the president and pressed the issue that apparently had gone unmentioned in previous talks with him that summer: the ongoing legal fight over compensation for the Black Hills.

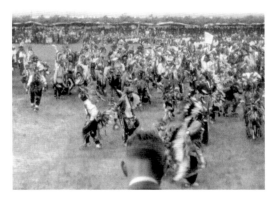

Native Americans dance for President Coolidge at the Pine Ridge Indian Reservation. *Keystone View Company, Library of Congress.*

The Sioux claim at the time amounted to $850 million, according to the *New York Times*. One Sioux leader read aloud to the president a prepared statement explaining the position of the tribes.

"We made treaties with the Government, which gave us this land forever," the statement said, in part. "Part of this land was taken from us and we are now trying to have this matter made right in the courts. We are too proud to ask for anything that is not ours by right, and all we ask is that our treaties be kept and that our lost lands be paid for....We do not want any money that is not ours, but we do want what is honestly due us."[153]

The president did not mention the Black Hills claim in his own speech, but he did deliver perhaps the longest of the few addresses he made during his nearly three months in South Dakota.

Ellen Agnes Riley, the White House's head housekeeper, was there and vividly recalled the silent respect shown by the Native Americans to the man described in the newspapers as their "Great White Father."

"I doubt if they could hear very well for the wind was the wrong way and they probably could not understand him anyway but there they stood, thousands of them, packed as close to the grandstand as they could get, faces painted, all gazing intently at the President," Riley wrote. "He spoke for twenty minutes and they never moved in all that time, faces upturned, arms folded, it was a most impressive sight."[154]

In her next breath, Riley reverted to stereotypical observations.

"But they are a very primitive people," she wrote, "their wants are few and they are very lazy. The Government has tried to make them farm, giving them the land, machinery etc. But they don't stick to it. They are very dirty."[155]

Coolidge's speech consisted mainly of an overview of the government's historically evolving policies toward Native Americans, focusing on historic wrongs and modern efforts to help them improve their lot in life. He spoke of his signing of the 1924 Indian Citizenship Act as a further step in the government's longstanding effort to "merge the Indians into the general citizenry and body politic of the nation."[156]

He also spoke about the extreme difficulty inherent in the government's dealings with tribes, delivering a summation of the situation that remains as true in some respects today as it was then.

"The Indian problem on its face appears to be one simply of effective social service, practical philanthropy and education. As a matter of fact, it is a many-sided question, complicated by puzzling complexities," Coolidge said.[157]

He went on to mention the 370 treaties and two thousand acts of Congress that pertained to Native Americans at that time.

"All of this mass of legislation, decisions, rules and regulations is complicated by the intrusion of the Indian's own tribal laws and customs and ways of doing things. The result, oft-times, has been confusion, much trouble and in too many cases injustice to the Indians."[158]

One of the people who was instrumental in bringing the president to Pine Ridge and who witnessed his speech was Charles H. Burke, a former congressman from South Dakota who was serving as the federal government's commissioner of Indian affairs.

In a letter written to Burke sixteen days before the president's visit to Pine Ridge, U.S. senator Peter Norbeck of South Dakota expressed optimism about the trip. "Much good, I am quite sure," Norbeck wrote, "will result from the President's visit to Pine Ridge."[159]

Sadly, that prediction did not hold up. Today, some Native Americans on the Pine Ridge Reservation are arguably worse off than their ancestors were in 1927. High rates of crime, unemployment, alcoholism and teen suicide are among the reservation's chronic problems.

The Sioux tribes did eventually win a settlement in their Black Hills land claim against the government. In 1980, the U.S. Supreme Court upheld an earlier lower-court ruling and awarded the tribes $106 million. But by then, the tribes had come to view a return of the Black Hills to their ownership as more important than monetary compensation, and because acceptance of the money would terminate their claim to the land, they have not accepted payment. The money has been earning interest ever since and has accumulated to more than $1 billion, according to numerous news reports.

RUSHMORE'S FIRST PRESIDENT

*The President's visit to South Dakota was a turning point in the
history of Mount Rushmore.*
—*Gilbert Fite, historian*[160]

Before Washington, before Jefferson, before Roosevelt, before Lincoln, there was Coolidge.

Had he not shown his face at Mount Rushmore in 1927, the other four presidential faces might never have been carved on the mountainside.

The idea to attract tourists by sculpting figures in the granite of the Black Hills was hatched four years earlier by South Dakota historian Doane Robinson. Eventually, with help from Senator Peter Norbeck and other key early backers, famed sculptor Gutzon Borglum was enlisted to take on the project and fundraising began.

Borglum surveyed the area for an appropriate site and settled on Mount Rushmore, a large granite formation that jutted up from the pine trees of the central Black Hills and faced a grand vista of forested slopes giving way to distant plains in the east. The mountain had been named rather randomly decades earlier for Charles E. Rushmore, a New York mining attorney who transacted some business in the Black Hills.

The first dedication of the Mount Rushmore project was conducted in 1925, but fundraising efforts floundered and carving did not commence. The project's few supporters feared it might not even get as far as Stone Mountain in Georgia, the carving of Confederate leaders that the

temperamental Borglum left unfinished when he stormed away from it following disagreements with the project's backers.

South Dakota historian Rex Alan Smith, author of a history of Mount Rushmore, was blunt about the project's early troubles.

"At the beginning of 1927," he wrote, "the Rushmore venture was near death and failing fast."[161]

News of Coolidge's potential choice of the Black Hills for a vacation, then, was welcome indeed. Borglum, Norbeck, Robinson and everyone else associated with the project knew that a presidential visit to the mountain and the nationwide publicity such a visit would generate could be just the thing needed to jolt the fundraising to life and perhaps even win support for federal funding.

And in fact, fundraising did pick up a bit during the spring and early summer as Coolidge arrived and began generating headlines from the Black Hills. Yet by the end of July, the association that was organized to fund the carving had only $28,000 on hand, according to an interview Robinson gave to a reporter.[162]

It was a start, though, and it gave Borglum, Norbeck and others some momentum as they lobbied for a presidential visit to the mountain.

Borglum, whose flair for the dramatic never failed him, grabbed the president's attention with a June 23 drop of a wreath onto the lawn of the State Game Lodge from a plane flown by local pilot Clyde Ice. On the wreath were a pair of moccasins, one bearing the words "Greeting from Mt. Rushmore to Mt. Coolidge," a reference to the legislature's naming of a Black Hills mountain in Coolidge's honor a day earlier.

That and other efforts to lure Coolidge to Mount Rushmore worked. He agreed to attend a second dedication of the project—a "consecration ceremony," some later called it, attempting to distinguish it from the earlier dedication—at which the actual carving would finally commence.[163] The date was set for Wednesday, August 10.

On that morning, hundreds of people who'd been advised by newspaper stories to get an early start drove their automobiles to the old mining settlement of Keystone, in a rugged portion of the Black Hills about twenty miles southwest of Rapid City and fifteen miles northwest of the State Game Lodge. Though some may have tried to drive the remaining three miles to the viewing area just below Mount Rushmore, the single-lane dirt road was in poor shape and most people walked. It was a strenuous hike with an elevation gain of about one thousand feet over the three-mile stretch.[164]

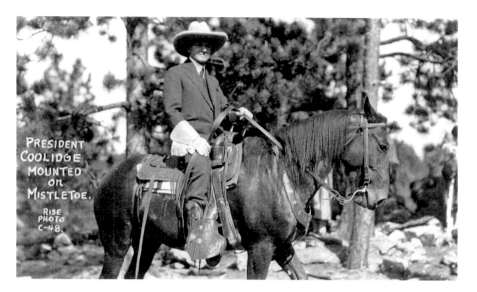

PRESIDENT
COOLIDGE
MOUNTED
on
MISTLETOE.

RISE
PHOTO
C-48.

President Coolidge on Mistletoe. *Rise Photo, Pat Roseland collection.*

Edmund Starling, Coolidge's Secret Service man, had arranged for some horses from the Custer State Park stable to be brought to Keystone. President Coolidge, without the First Lady but with several other companions, rode to Keystone in a car and then mounted Mistletoe, the horse he'd ridden previously in the state park, for the final leg of the journey up to the base of Mount Rushmore.

Coolidge tucked the pants of his business suit into a pair of riding boots and wore fringed, cavalry-style leather gloves. The look was completed with his trusty ten-gallon hat.

Riding horses with the president were at least one visiting dignitary, Senator Simeon Fess, of Ohio, plus Starling and some of the president's aides. When they reached the ceremony site prior to the 2:30 p.m. start time and dismounted, a series of dynamite blasts like a twenty-one-gun salute was set off down along the road to Keystone. The blasts served the additional purpose of ridding the roadway of tree stumps.[165]

The president removed his gloves but kept his hat on and his pants tucked into his boots as he stepped up onto a wood-plank platform and sat down on one of the big, padded wooden chairs set up for the dignitaries, who were surrounded by a crowd of about 1,500 people. Senator Norbeck, seated beside the president, served as the ceremony's emcee.[166]

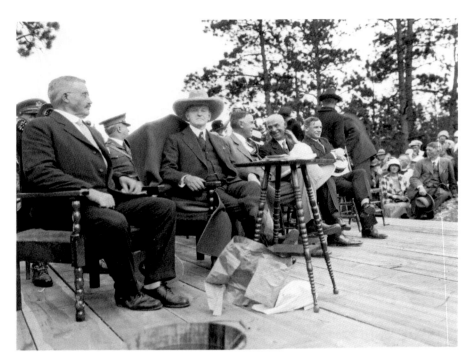

President Coolidge, in a giant cowboy hat, sits on the platform during the 1927 dedication of Mount Rushmore and is flanked by Senator Peter Norbeck (*left*) and Governor William Bulow. *Archives and Special Collections, University Libraries, University of South Dakota.*

Everyone joined in the singing of the first verse of "America" ("My Country 'Tis of Thee") to open the program, and an Episcopal bishop gave an invocation.[167]

Norbeck introduced President Coolidge, who finally removed his huge hat. Standing on the wood-plank stage, his pants still tucked into cowboy boots that rose nearly up to his knees, Coolidge put on his reading glasses, held the sheets of paper bearing the text of his address in one hand and looked down as he read it.

His thin voice carried only to the people nearest the stage, but that was no matter. The people in the crowd likely knew that the speech would be printed later that day in the *Rapid City Journal*, and they'd grown accustomed to hearing nothing from Coolidge anyway. Besides some brief comments uttered here and there during the two months he'd been in the Black Hills to that point, this was the first official address he'd delivered.

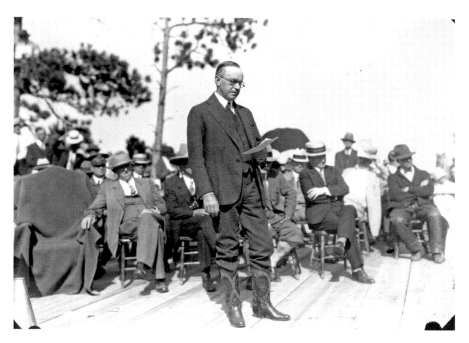

President Coolidge delivers his address during the dedication and beginning of carving at Mount Rushmore. *A.B. Kellogg Scrapbook, Rapid City Public Library.*

The speech covered the reasons for including each of the four presidents in the carving. The justification for three was obvious and needed little explanation, and Coolidge dealt with them first: George Washington represented the country's founding; Thomas Jefferson, its expansion with the Louisiana Purchase; and Abraham Lincoln, its preservation through the Civil War.

Theodore Roosevelt had been dead only eight years and had practiced a brand of progressive politics at odds with Coolidge's staunch conservatism. The reason for Roosevelt's inclusion in the carving was not as easily explainable, but Coolidge gave it his best shot. Alluding to Roosevelt's trust-busting ways, Coolidge said that "to political freedom" Roosevelt "strove to add economic freedom." Additionally, by shepherding construction of the Panama Canal, Roosevelt "brought into closer relationship the East and the West and realized the vision that inspired Columbus in his search for a new passage to the Orient."

Much of the rest of the speech showered praise on the proposed carving, its setting and the people trying to make it happen.

"The fact that this enterprise is being begun in one of our new States, not yet great in population, not largely developed in its resources, discloses

that the old American spirit still goes where our people go, still dominates their lives, still inspires them to deeds of devotion and sacrifice," Coolidge said, in part.

Then, near the end of the speech, the president said something that probably made the dignitaries on the stage perk up. The spendthrift president surprisingly cracked open a verbal door to the possibility of federal financial support of the carving.

"Money spent for such a purpose is certain of adequate returns in the nature of increased public welfare," Coolidge said, winding up to two of the most important sentences in South Dakota history: "The people of South Dakota are taking the lead in the preparation of this memorial out of their meager resources, because the American spirit is strong among them. Their effort and courage entitles them to the sympathy and support of private beneficence and the National Government."

It was an emphatic and clear statement of support that must have made Robinson, Norbeck and the project's backers swell with pride. The president hadn't said the project was merely "worthy" or "deserving" of support. He said the project "entitles" the backers to support, and not just private donations but also the aid of the federal government.

A pledge of monetary support was no small thing from a president who was known for his miserly management of the federal budget and for cutting the national debt.[168] It was perhaps the mixture of his lightened mood, his desire to appease westerners and his patriotism that loosened him up. Two years later, in what read like a defense of the federal dollars he committed to Mount Rushmore, Coolidge explained in his autobiography that his fiscal philosophy was "by no means a doctrine of parsimony."

"Both men and nations should live in accordance with their means and devote their substance not only to productive industry," he wrote, "but to the creation of the various forms of beauty and the pursuit of culture which give adornments to the art of life."[169]

Back at Rushmore, during Coolidge's speech, a local pilot flew over the spot where Washington was to be carved and dropped a laurel bearing the name "Washington" onto the mountain, followed by a drop of telegrams from governors of various states and from other notable people. It was all part of a theatrical plan orchestrated by Borglum, who proceeded to perform the event's crescendo.

At the conclusion of Coolidge's speech, the president presented Borglum with six drill bits that were specially obtained for the occasion. Borglum, dressed in baggy, knee-length knickers and high socks, gave his own bravado-filled speech

Mount Rushmore, as it appeared the day carving began in 1927. A pine mast used during a flag-raising ceremony is visible atop the mountain. *A.B. Kellogg Scrapbook, Rapid City Public Library.*

and then turned to climb the 1,400-foot plank stairway that had recently been installed for workers to reach the top of the mountain.

The crowd's patience was rewarded when one of Borglum's workers lowered him over the face of the mountain in a bosun chair, which looked like a swing. There, dangling in front of the rock face at nearly six thousand feet above sea level, Borglum dramatically began the carving of Mount Rushmore by manhandling a heavy drill and using each of the six drill bits—which were to be given to dignitaries later—to drill six holes where the carving of Washington was to begin.

An elaborate ritual followed in which the flags of France, Spain, France again and then the United States were sent up a pine mast atop the mountain to signify the ownership succession of the Louisiana Territory, of which the Black Hills had been a part.

More singing and more speeches by other dignitaries followed. Rolf Lium, the college student who'd been ministering to the Coolidges all summer at the Hermosa Congregational Church, was given the honor of delivering the closing prayer.

During Borglum's speech, he expounded on his plan to chisel a massive inscription onto the mountain, along with the presidential figures, "where will

be recorded the steps taken to found, expand and preserve and develop the United States." He invited Coolidge to write the inscription, which seemed a natural given Coolidge's status as president, his importance to the beginning of the carving and his reputation for brevity, which would be necessary to cram the story of the nation into the planned 120- by 80-foot space using giant letters.

Three years later, Borglum edited Coolidge's draft of the inscription without the president's knowledge or permission and released the edited version to the press. After some readers criticized the quality of the writing, Borglum admitted to editing it, and the resulting public controversy led Coolidge to withdraw from the project.

As the carving dragged on past its originally anticipated five-year completion date and racked up bills beyond its initial $437,500 budget, Borglum gave up on the inscription. Plans to carve the presidents to their waists also fell away, but the faces were mostly complete by the time Borglum died in March 1941. Carving officially ended later that year.

The carving took fourteen years from start to finish. Nearly $1 million was spent on the project, about four-fifths of it from the federal government.[170] Coolidge helped turn on the federal spigot not only with his speech in 1927 but also with his signing, one week before he left office in 1929, of legislation providing $250,000 of federal money to be matched by private donations.

Today, most Americans do not think "Coolidge" when they think "Rushmore," but there is wide agreement among Rushmore historians about Coolidge's vital role in the project.

Suzanne Barta Julin, author of a book on the history of Black Hills tourism titled *A Marvelous Hundred Square Miles*, wrote that Coolidge's "presidential patronship" during his 1927 vacation "opened the door" to federal funding and "made the Mount Rushmore National Memorial a reality."[171]

Rex Alan Smith wrote in *The Carving of Mount Rushmore* that if it hadn't been for the special circumstances that brought Coolidge to the Black Hills and to Mount Rushmore in 1927, the carving "probably would never have been created."[172]

John Taliaferro, author of the Rushmore book *Great White Fathers*, expressed a belief that "Mount Rushmore might never have materialized" without Coolidge's visit.[173]

Today, Mount Rushmore National Memorial attracts more than 2 million visitors annually and serves as the engine powering a nearly $4 billion tourism industry in a state with only 850,000 residents.[174]

Sadly, Calvin Coolidge did not witness any of that success. A month after the dedication ceremony, he boarded a train bound for Washington, D.C., leaving South Dakota behind. Less than six years later, he was dead.

PART III
AFTERMATH

13

SOUTH DAKOTA SURPRISE

Isn't that just like the man! He never gave me the slightest intimation
of his intention. I had no idea!
—*Grace Coolidge*[175]

W hen President Coolidge took his automobile ride to Rapid City on the
morning of August 2, 1927, he harbored one of the nation's best-kept
secrets.

Even Edmund Starling, the Secret Service man who was routinely at the
president's side, apparently did not know the president had chosen that day
to make an announcement. But Starling did claim to be one of the earliest,
and possibly the first, to learn of Coolidge's desire to leave office rather than
run for reelection.

Years afterward, Starling recalled a conversation he had with Coolidge
during the weeks leading up to the South Dakota trip. Starling and the
president were talking about the Black Hills, and Starling said he'd been so
impressed by the region while scouting it that he was thinking about leaving
the Secret Service detail at the end of the president's term and moving to the
Black Hills to buy a cattle ranch.

Coolidge supposedly answered by encouraging Starling to remain at his
side through 1928 and beyond—but not at the White House.

"We can take a nice long trip across the country as soon as my term is over,
and do all the hunting and fishing we want to without anybody bothering
us," Coolidge said, according to Starling. "Then you can stay with me.
Maybe I can get a job somewhere."[176]

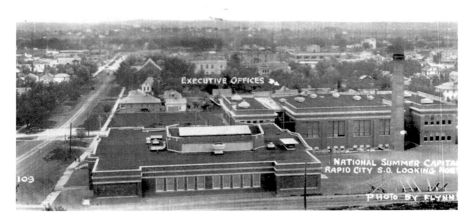

A 1927 bird's-eye view of Rapid City High School, site of President Coolidge's summer office. This view is from the rear of the building, looking toward downtown Rapid City. *Photo by Flynn's, Pat Roseland collection.*

The meaning of the words slipped past Starling at first, but soon he realized what the president was saying. If Coolidge was planning to hunt and fish whenever he wanted, and if he was talking about getting a job, he was not planning to be president.

That's where their discussion of the matter ended. The only person who knew the announcement would be made August 2 was Everett Sanders, whose duties as Coolidge's executive secretary were akin to a modern-day chief of staff.

Sanders recalled being summoned in late July to the president's office in Rapid City High School, where the president related his decision not to run for another term and showed Sanders a written announcement to that effect.

"The one impression that I had, and which still remains, was that he had not called me in to seek my advice as to whether he should run," Sanders later told a Coolidge biographer. "After we discussed the phraseology of the note which he had submitted to me, I knew that he had not the slightest idea of heeding my advice about that unless I should agree."[177]

Nobody else was let in on the secret, least of all the press. Speculation about Coolidge's future had continued throughout the summer, and as

recently as July 11, the *New York Times* had published a story under the headline, "Coolidge Visitors Say He Is Candidate."

On the morning of the big day, Sanders gave Coolidge's handwritten note to Edwin Geisser, the president's stenographer. The surprised stenographer made copies, either by writing or typing the president's message five or six times on legal-sized paper and using carbon sheets to produce additional copies. Geisser gave the papers to the president, who used scissors to cut them into individual slips for the three dozen or so reporters in the press corps.[178]

Then came the momentous scene in the president's office, where he silently distributed the slips of paper to the reporters, refused to answer their questions and watched them dash out the door.

Coolidge rode back to the State Game Lodge that afternoon with Arthur Capper, a Republican U.S. senator from Kansas and the publisher of several farm journals, who had come to discuss farm policy with the president.

Capper had lunch at 1:30 p.m. at the State Game Lodge with the president and the First Lady, and nobody spoke of the announcement. When the meal was finished, the president slipped away for his usual afternoon nap.

Left to pass the time with the First Lady, Capper finally broached the subject of the day's big news.

"That was quite a surprise the president gave us this morning," he reportedly said.[179]

Confusion registered on the First Lady's face. She apparently had no idea what had happened in Rapid City until Capper told her. Similar expressions appeared on the faces of Americans across the country as the news spread.

"I do not choose," the little slips of paper had said, "to run for president in nineteen twenty eight."

It was an enigmatic statement befitting an enigmatic man. At just twelve words, it was severely brief, and yet it was also verbose, with the year 1928 written as words instead of digits and the clunky phrase "do not choose" casting an ambiguous shadow over the entire sentence.

Coolidge's use of that phrase instead of something

The original, handwritten note by President Coolidge that was copied and distributed at a press conference on August 2, 1927, at Rapid City High School. The note reads, "I do not choose to run for president in nineteen twenty eight." *Library of Congress.*

shorter and clearer, like "will not," prompted the press and the public to engage in rampant speculation. Did he mean that he did not choose to make himself a candidate but would accept if the Republican Party chose to nominate him? That was the opinion of many around the country on the day of the announcement and for months afterward.

Starling later explained that in the rural vernacular of Coolidge's native Vermont, the phrase "do not choose" was a strong and clear statement of intent.

"To a Vermont Yankee nothing is more emphatic than, 'I do not choose.'" Starling wrote. "It means, 'I ain't gonna do it and I don't give a dern what you think.'"[180]

Others made the same observation, but that did not stop the popular quest to decode the supposedly hidden meaning of the president's words. Coolidge did little to discourage the obsession, at least at first.

Starling thought the president was toying with the press.

"The sensation caused by his announcement tickled the President," Starling wrote. "He liked to do things which caused little and foolish men to scamper about and make a fuss."[181]

The scampering and fussing continued until and beyond the president's last day in the Black Hills, September 9. That day, the president's former executive secretary, C. Bascom Slemp, returned to the East Coast from an overseas trip and announced that he did not believe Coolidge intended to take himself entirely out of the presidential race. Slemp focused, like everyone else, on the president's peculiar word choice.

"If a man has definitely made up his mind it is so much easier to say 'I won't run,'" Slemp was quoted as saying. "I don't know, of course, but it is my personal belief that Mr. Coolidge would respond to a free expression of the popular will."[182]

At the State Game Lodge, it took two army trucks to haul the presidential party's 142 chests to the train in Rapid City, plus two more trucks to haul the rest of the baggage and supplies. Two buses hauled the Secret Service men, servants and menagerie of presidential pets, including Rebecca the raccoon, Rob Roy the collie dog and three new dogs the Coolidges were given in the Black Hills. The new dogs were a white collie, Diana of Wildwood, aka Calamity Jane; a brown chow-chow, Tiny Tim; and a black chow-chow, Blackberry.[183] Two sheep given to the president on September 1 at the Butte County Fair in Nisland, South Dakota, were shipped separately to the president's family farm in Vermont. The horse, Kit, given to the president by Boy Scouts on his birthday, was reportedly given back to the Scouts.

An estimated five thousand people gathered at Rapid City High School for a late morning farewell ceremony on September 9 where the president gave a brief speech, hours ahead of the presidential train's departure that night. It had been almost three months since the Coolidges departed Washington, D.C., and except for the time spent in transit and a week's side trip to Yellowstone National Park near the end of August, they'd spent the entire time living, working and playing in and around the Black Hills.

People once again gathered along the railroad tracks at points throughout South Dakota to watch the train pass by. The train made an extended stop September 10 in the South Dakota city of Brookings, where the president delivered a dedicatory address at South Dakota State College for the Lincoln Memorial Library, laid the cornerstone of the college's Coolidge Sylvan Theatre and received an honorary doctor of science degree.

While departing Rapid City, the president succinctly summarized his experience in the state.

"We have had a very pleasant and, I might say, very wonderful summer," he said.[184]

14

WHY DIDN'T HE CHOOSE?

On the whole, the president's trip seemingly convinced him that his veto was more popular...than some of the more vocal friends of the farmer would have led him to believe.
—Gilbert Fite, historian[185]

Whatever Calvin Coolidge intended to communicate with his terse message on August 2, 1927, he eventually showed by his actions that he was serious about stepping away from the presidency. He did not campaign for the Republican Party's nomination and did not condone efforts to nominate him. The party eventually nominated Herbert Hoover, who won the general election in 1928 to become the next president.

Questions remain about exactly when Coolidge made his decision not to run and why. Because he had been vacationing in South Dakota for about two months by the time of his announcement, the search for answers must pass through the Black Hills.

What little Coolidge revealed himself is in his autobiography, published in 1929.

"I had never wished to run in 1928 and had determined to make a public announcement at a sufficiently early date so that the party would have ample time to choose some one else," he wrote. "An appropriate occasion for that announcement seemed to be the fourth anniversary of my taking office."[186]

Coolidge became president in 1923 upon the death of President Warren Harding and served the final 19 months of Harding's term. Then Coolidge won and served his own four-year term. If he had won and

served another term after that, it would have pushed his total time in office to nearly ten years.

There was no lawful limit on presidential terms at the time, but the tradition of serving no more than two terms had persisted since George Washington. Some said another four years for Coolidge would have amounted to an unprecedented third term, and while Coolidge did not necessarily agree with that assessment, he acknowledged that "it is difficult to conceive how one man can successfully serve the country for a term of more than eight years."[187]

His autobiography listed numerous other factors in his decision, including his desire to escape what he called the "appalling burden" of the presidency. He said the "power and the glory" of the office had vanished when his younger son died.[188]

Coolidge also mentioned a concern for Grace's health and a sense that his own work was done. He had significantly reined in the federal government and made sizable budget cuts, and many Americans were enjoying the surge of prosperity for which the Roaring Twenties came to be known.

Things changed quickly after Coolidge left office on March 4, 1929. The stock market crashed on October 29 that year; the Great Depression ensued; and Coolidge's successor, Hoover, suffered the popular blame. Whether Coolidge had any inkling of the impending economic collapse, and whether that influenced his decision to return to private life, continues to be a topic of debate.

Coolidge did not say whether his 1927 summer vacation had any influence on his decision. If anything, it appeared that the lack of strong sentiment against him in the West may have convinced him that the Republican Party could survive his retirement.

When Coolidge went to the Black Hills, many assumed he intended to shore up support for his reelection bid among farmers angered by his veto of the McNary-Haugen farm bill. That assumption was exploded by Coolidge's August 2 announcement that he would not run for president in 1928.

It's possible that Coolidge went west not to shore up his own political standing, but rather to gauge the damage that his McNary-Haugen veto had done to the Republican Party and to repair any such damage before he left office.

That theory would help explain the change in demeanor and behavior that Coolidge underwent in the Black Hills. The uncharacteristically boyish sense of freedom that he displayed—donning cowboy outfits, going horseback riding, climbing down from a lumber wagon to help push it up a muddy hill—may have arisen not only from a desire to win the affection of

western farmers but also from a liberating realization, derived from personal exposure to farmers and farm leaders, that press reports of popular outrage over his McNary-Haugen veto were overblown.

Any personal animosity westerners felt toward Coolidge because of the veto was partially wiped away by his embrace of western culture, according to his private secretary, Edward T. Clark.

"His visit has removed largely that personal feeling," Clark wrote in a late June 1927 letter from Rapid City to Coolidge's main political backer, Frank Stearns, in Boston. "There is still a very widespread demand for agricultural relief, which has not abated here, but the bitterness over the veto toward a man whom they regarded as cold and unfeeling has disappeared."[189]

Some McNary-Haugen evangelists kept up their campaign throughout the summer to change the president's mind about the bill. But Coolidge heard a variety of dissenting opinions during private conferences with farm state leaders who journeyed to the State Game Lodge, and during visits with rank-and-file farmers at events such as a three-state farmer picnic he attended in July at Ardmore, south of the Black Hills.

The deeper Coolidge probed the farm situation, the softer the support seemed for the hard line, pro–McNary-Haugen stance of the congressional Farm Bloc. Walter Travis, a South Dakota political columnist who covered

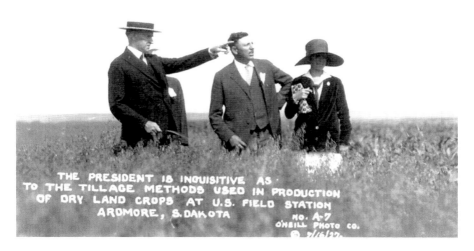

President Coolidge discusses farming methods at the U.S. Field Station near Ardmore. *O'Neill Photo, Pat Roseland collection.*

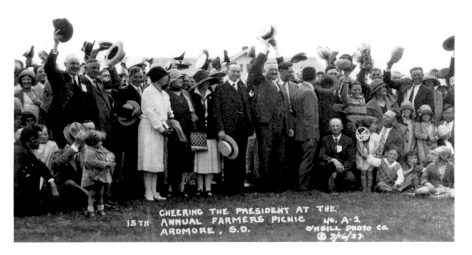

Attendees cheer the president at the fifteenth annual Ardmore Farmers Picnic on July 16, 1927, in southwestern South Dakota. *O'Neill Photo, Pat Roseland collection.*

the president's vacation, noted that the presidential press corps found the political uprising among farmers to be a phantom menace.

"How is it," one eastern reporter asked Travis, "that I've talked to everyone from the Middle West I've met and outside of your congressional delegation not one of them is for this McNary-Haugen bill?"

Travis said the comment was "just one of a number of its kind since the president arrived."[190]

Even among farmers who supported the McNary-Haugen bill, a wet summer and good crops blunted their sense of urgency. By the end of August, precipitation in the Rapid City area was six inches above normal.[191] The growing season was so good that an editorial in Pierre's *Capital Journal* declared, "South Dakota has the greatest crop prospect it ever had as a state."[192]

It all added up to disappointment for South Dakota's U.S. senator Peter Norbeck, who had hoped to convert Coolidge to McNary-Haugenism but instead watched helplessly as the president's opposition to the bill was further cemented. Norbeck's mood was improved, of course, by the other benefits of the presidential vacation, including a boost to tourism and the dedication of Mount Rushmore.

Coolidge ultimately lent his support to an alternative, less ambitious farm relief plan that emerged during the summer, while members of the congressional Farm Bloc refused to let the McNary-Haugen bill die. They pushed the bill through Congress again in 1928, only to suffer another

Coolidge veto. Hoover ended up inheriting the unresolved problem of agricultural relief when he became president, and Hoover's successor, Franklin Roosevelt, finally overhauled farm policy during the 1930s in response to the Great Depression and Dust Bowl.

When Coolidge delivered his farewell speech to the people of Rapid City on September 9, 1927, he took the opportunity to note that the farm situation appeared to be improving:

> *I have visited some of the Federal projects in South Dakota, the dry farming experiment station and the reclamation and irrigation projects. I am glad to see that they are all working so successfully.*
>
> *I have seen the country developed through the growing season of the Summer, the stacks of alfalfa rising up on the lowlands, the corn, the wheat and the oats and cattle, all of them becoming ready for harvesting and the market.*
>
> *I judge from what has been told me, and from my own observation, that you have had a successful season throughout this locality and this neighborhood.*[193]

Days earlier, the *Rapid City Journal* published reports of nine-foot-tall corn in western South Dakota.[194] In the shadow of those tall crops, it seemed, Coolidge had found some of the political cover he needed to exit the national stage.

In the end, that may have been the extent of the role that the Black Hills and South Dakota played in the termination of the Coolidge presidency. The positive agricultural mood he found in the state may have simply encouraged Coolidge to follow through on a decision he had already made.

Historian Robert Ferrell, who wrote books about both Coolidges, suggested in a biography of the First Lady that another factor in President Coolidge's decision to forgo a 1928 campaign may have been the so-called Haley affair, a reference to the president's angry dismissal of Secret Service man Jim Haley after Haley got lost with the First Lady on a Black Hills hike. "In the Haley affair," Ferrell wrote, the president "realized his incapacity to handle the pressures of the presidency and the marriage." After President Coolidge threw off the yoke of a campaign and another term, Ferrell reported, the Coolidge marriage improved.[195]

It remains tempting to think that in addition to or instead of all the aforementioned reasons for Coolidge's decision to abandon a reelection bid, the beauty of the Black Hills may have inspired him toward an epiphany that precipitated the decision. A *New York Times* correspondent indulged that line of thinking on the day of Coolidge's "do not choose" announcement.

"The solitude of his mountain retreat, the change in environment and his communion with the mysteries of nature have given the President opportunity for introspection," the correspondent wrote. "He has been very much alone. He has held conferences. He has received visitors. He has attended local functions. But chiefly he has been holding communion with his own thoughts."[196]

Those thoughts remained mostly trapped in Coolidge's mind, so we may never know exactly what influence the Black Hills exerted on his decision-making. The region will forever retain an undeniable place in Coolidge lore, though, for as historian Suzanne Barta Julin has artfully noted, "Coolidge had brought the presidency to the Black Hills and relinquished it there."[197]

And because of that, she added, "The Black Hills were on the map."[198]

LEGACY

*The publicity the Black Hills is getting will return untold dividends, and the
people here do not realize what results it is going to bring.*
—U.S. senator Peter Norbeck, South Dakota[199]

The presidential train arrived back in Washington, D.C., at ten o'clock
on the night of September 11, 1927. It had been ninety days since the
Coolidges and the rest of the presidential party last set foot in the nation's
capital.

Calvin Coolidge never returned to South Dakota. He left office at the end
of his term in March 1929, and nearly four years later, on January 5, 1933,
he died of a heart attack. He was sixty years old.

In the decades since the Coolidges made the Black Hills their summer home,
the region has continued to reap the benefits. The president's most obvious
Black Hills legacy is the momentum that his endorsement of Mount Rushmore
contributed to a carving project that has since attracted millions of people.

An overlooked legacy of similar importance arose from President
Coolidge's signing, on his very last day in office on March 4, 1929, of
legislation granting national monument status to roughly eighty square miles
of South Dakota's Badlands.

The legislation was shepherded through Congress by Senator Peter
Norbeck and Representative William Williamson, who were instrumental in
bringing Coolidge to South Dakota and spent considerable time with him
there. The first couple did not visit the Badlands themselves, but on their
second-to-last day in the Black Hills, they did view fossils from the Badlands

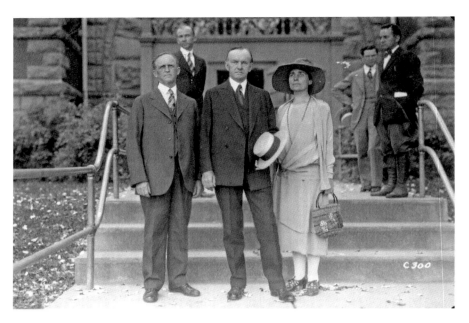

C.C. O'Harra, president of the South Dakota State School of Mines, poses with Calvin and Grace Coolidge, probably on the day they toured the school's museum and saw its Badlands fossils. *A.B. Kellogg Scrapbook, Rapid City Public Library.*

housed at the South Dakota State School of Mines in Rapid City. Their son, John, who was visiting them at the time, took a fifty-mile drive to the Badlands that same day with one of the president's aides.[200]

For Norbeck, the protection of the Badlands' beautifully eroded and striated formations of sedimentary rock was a longtime ambition. The national monument bill was the result of legislative work he'd been doing since at least 1922, when he first introduced a bill to make the Badlands a national park.[201] He died in 1936, and Williamson died in 1972; neither lawmaker lived to see the re-designation of the Badlands from a national monument to a national park in 1978.

Today, Badlands National Park encompasses 380 square miles. In 2015, it attracted 1 million visitors.[202]

Even if the Badlands had not been formally protected, and perhaps even if Mount Rushmore had not been carved, the Black Hills tourism industry still would have benefitted from the surge of publicity generated by the Coolidge vacation.

During the eighty-eight-day span from the Coolidges' arrival in the Black Hills until their departure, and including their week in Yellowstone,

reporters and correspondents covering the president sent roughly 2.1 million words over the telegraph wires.[203]

The *Rapid City Journal* staff of 1927 attempted to put that into perspective by calculating that if all those words were printed one after the other, they would have required more than three hundred pages of newsprint. Based on the *Chicago Tribune*'s 1927 full-page advertising rate of $5,000, the *Journal* reported, the cost for that much advertising would have been $1.575 million.[204] In inflation-adjusted 2017 money, that would be almost $22 million.

And those figures were conservative, considering that many of the stories written by the three dozen or so members of the presidential press corps not only were printed in their own newspapers but were also distributed by news services to hundreds of additional papers. And there were an untold number of stories about the Black Hills published even before the presidential vacation, as reporters scrambled to learn more about the site of the Summer White House.

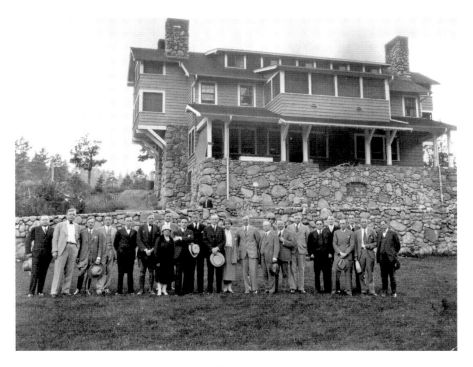

The Coolidges stand in front of the State Game Lodge with some of the newspaper correspondents who spent the summer covering the president in the Black Hills. *Rise Photo, Pat Roseland collection.*

Some of the stories filed by the presidential press corps during the president's visit had little to do with the Black Hills, such as reports of the president's thoughts on various national policy matters, but nearly all of the stories included a "RAPID CITY" dateline, which helped to ingrain awareness of the place in the national psyche. And there were plenty of stories about the Coolidges' adventures in the Black Hills, and about the scenic beauty the first couple encountered there. Some papers, including the *New York Times*, ran full-page photo spreads of Black Hills scenes. The print coverage was augmented by video newsreels of the Black Hills and of the president's vacation that were shown in theaters across the country.

The positive effect of the publicity was foretold in June 1927 by a man named Jesse Simmons, a former resident of the Black Hills city of Deadwood.

"Coolidge's visit to my mind is a re-discovery of the Black Hills," Simmons said the week of the Coolidges' arrival, "second only in importance to the first discovery of gold, and will be the beginning of another stampede."[205]

The stampede began immediately as visitors rushed to get a glimpse of the president and to see the place he had chosen for his vacation.

Through June 17, 1927, the month's count of cars registered at Rapid City's municipal camping park was 594, an increase of 124 over the same date from the previous year.[206]

During a stretch of several days in July, 350 to 400 tourists per day were stopping at the Rapid City Commercial Club office to seek information on roads, distances and places of interest. They constituted "only a part of the great throng of tourists" in the area, the *Rapid City Journal* noted.[207]

July numbers at a campground in Hot Springs, in the southern Black Hills, rose to 2,765 cars from 2,008 the previous July.[208] Some automobile travelers came in herds, like the Iowa caravan of 100 cars and a Canada caravan of 40 that both came in late July.[209]

The motoring tourists all needed gasoline, and statewide gas tax collections soared. In June, collections were $285,152.06, which was the biggest haul since the $0.03-per-gallon tax had been implemented in March 1925. The tax rose to $0.04 per gallon in July 1927 because of an earlier decision by the legislature, which drove collections even higher.[210]

Much of the gas tax revenue went to the state's highway fund to build, surface and maintain roads, which were of vital importance to the booming tourism industry. Besides improving roads specifically for the president, the State Highway Commission scrambled to improve other roads traveled by tourists. As the summer drew to a close, the commission announced plans to surface with gravel the remaining dirt portions of U.S. Highway 14 and

make it the first road to be graveled all the way from one side of the state to the other. Graveling was also planned on most of U.S Highway 16 across the state, much of which would be supplanted decades later by Interstate 90.

"Work on these two main routes across the state was rushed this summer," the *Rapid City Journal* reported in August 1927, "particularly following President Coolidge's decision to establish the summer white house in the Black Hills."[211]

Beyond influencing vacationers, President Coolidge also showed eastern business travelers that they could go west without interrupting their work. Newspapers frequently reported the ease with which the president conducted his business thanks to airmail, telephones and telegraphs.

An editorial by the *Jerseyman* newspaper of Morristown, New Jersey, said the president had "dissipated the myth of distance."

"He has made plain to the business people of the east that the western trip, which they have all been promising themselves, need no longer be postponed to the time when they can afford to cut away from business," the editorial said, "because whether their journey takes them to the Black Hills, or even beyond, they will find ready and waiting for them not only the convenience which will allow them to carry on business as usual, but a change of scene which will inspire them with new business vigor."[212]

In addition to President Coolidge's influence on early automobile travelers and telecommuters, he and First Lady Grace Coolidge left behind a number of physical reminders of their vacation in the Black Hills.

The State Game Lodge still stands in Custer State Park, and it looks much the same as it did in 1927. Visitors willing to pay a premium can stay in a period-decorated room where President Coolidge slept.

One of Custer State Park's highest peaks is still named Mount Coolidge, and the stream that flows past the State Game Lodge is still named Grace Coolidge Creek.

The Rapid City campus where Coolidge had his summer office in 1927 was the site of three structures—the old high school; the so-called east wing of a new high school, the remainder of which was yet to be built; and an elementary school. The old high school, which housed Coolidge's office and hosted the distribution of his famous "do not choose" statement, was razed after a 1970 fire in the adjacent elementary school. Construction had meanwhile continued on the new high school, which was completed in 1937.[213] That building still stands, including the east wing portion that stood during 1927. Today, the building houses an alternative high school and performing arts center.

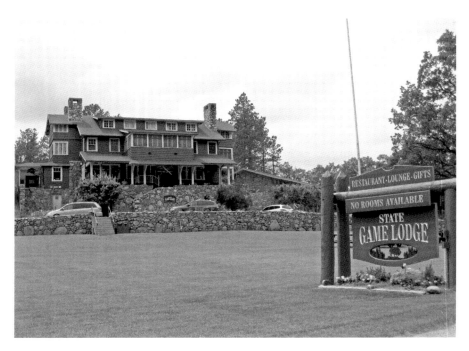

The State Game Lodge in Custer State Park during the summer of 2015. *Author's collection.*

Many of the gifts the Coolidges received while in South Dakota, including the feathered headdress given to the president, are housed at the Calvin Coolidge Presidential Library and Museum at the Forbes Library in Northampton, Massachusetts, which is the city the Coolidges called home.

So, the legacy of the 1927 Summer White House lives on in places such as Custer State Park, Mount Rushmore, Rapid City, the Badlands and even Massachusetts. As new generations rediscover the story of Calvin Coolidge in the Black Hills, perhaps South Dakota will continue to benefit from visitors inspired by his example. After all, if a president of the United States liked the Black Hills enough to stay there for nearly three months, there must be something special about those rocky, pine-covered mountains.

Even Silent Cal Coolidge could not help but express that.

"I doubt if one went to any part of the country," he said, "that he would find it more interesting and more inspiring than this locality and region."[214]

Timeline

Selected events from before, during and after the 1927 Coolidge summer vacation in the Black Hills:[215]

March 10, 1926: Albert M. Jackley, of Pierre, South Dakota, writes a letter to South Dakota congressman William Williamson that indicates they have discussed the possibility of inviting President Calvin Coolidge to spend the summer in the Black Hills.

March 30, 1926: Francis Case, publisher of the *Hot Springs Star* (and future U.S. representative and U.S. senator) wires Williamson and urges him to formally invite the president to vacation in the Black Hills during the summer of 1926. Williamson complies, but the president ultimately chooses the Adirondacks of New York.

January 8, 1927: The South Dakota legislature passes a resolution inviting President Coolidge to spend his 1927 summer vacation in the Black Hills.

February 25, 1927: President Coolidge vetoes the McNary-Haugen farm relief bill, angering members of the congressional Farm Bloc from the Midwest and West.

March 8, 1927: The White House says the president will vacation somewhere in the West during the summer of 1927.

May 12, 1927: Edmund Starling, head of President Coolidge's Secret Service detail, arrives in the Black Hills and spends two days scouting the area. He returns in late May to monitor preparations for the presidential vacation.

May 31, 1927: The White House announces that the Coolidges will arrive in mid-June to spend the summer at the State Game Lodge in South Dakota's Custer State Park. Rapid City High School is announced as the site of the president's summer office.

June 13, 1927: The Coolidges, among a party of about eighty, including staff, servants, Secret Service men, reporters and photographers, leave Washington, D.C., by train.

June 15, 1927: The presidential train stops in Pierre, and the Coolidges visit the state capitol before continuing on to Rapid City. From there, they are driven by car to the State Game Lodge in Custer State Park.

June 16, 1927: The president gets his first taste of Black Hills fishing and catches five trout.

June 17, 1927: The president uses his Rapid City High School office for the first time.

June 18, 1927: At the Game Lodge, the president meets with several hundred members of the National Editorial Association and Governor Adam McMullen of Nebraska.

June 19, 1927: The first couple attend church in Hermosa for the first time, where twenty-year-old Rolf Lium delivers his first-ever sermon.

June 21, 1927: President Coolidge reviews 1,200 national guardsmen in camp west of Rapid City. He receives a delegation from Belle Fourche, which invites him to attend the Tri-State Roundup and presents him with a ten-gallon cowboy hat.

June 22, 1927: The South Dakota legislature changes the name of Sheep Mountain to Mount Coolidge.

June 23, 1927: Local pilot Clyde Ice, with Gutzon Borglum as a passenger, flies over the State Game Lodge and drops a wreath with the message "Greeting from Mt. Rushmore to Mt. Coolidge." General Leonard Wood arrives from the Philippines, and the president also receives U.S. House Majority Leader John Tilson, of Connecticut, and Representative Charles Winter, of Wyoming.

June 25, 1927: Two hundred members of the legislature, with South Dakota U.S. senators Peter Norbeck and William McMaster, visit the Coolidges and then travel to the top of Mount Coolidge to formally dedicate it.

June 27, 1927: When the president arrives at the Game Lodge for lunch, Mrs. Coolidge is not there. After she shows up and explains that she and her Secret Service man, Jim Haley, got lost on a hike, the president soon reassigns the Secret Service man to duty in Washington, D.C.

June 29, 1927: The president reviews the Fourth U.S. Cavalry in front of Rapid City High School.

June 30, 1927: The state legislature changes the name of Squaw Creek in Custer State Park to Grace Coolidge Creek at the suggestion of South Dakota's only female legislator, Mary Kotrba.

July 4, 1927: During the president's fifty-fifth birthday celebration at the State Game Lodge, the Custer Boy Scouts give him a riding pony with tack, and a band from Terry, Montana, gives him a pair of chaps. Many birthday cakes are presented to the president.

July 5, 1927: The Coolidges attend the Tri-State Roundup rodeo in Belle Fourche.

July 7, 1927: James Sheffield, ambassador to Mexico, arrives at the Game Lodge. The Coolidges visit the Rapid City Indian School.

July 12, 1927: The president is visited by Wyoming's Governor Frank Emerson, U.S. senator John Kendrick and faculty and students of the Spearfish Normal School.

July 15, 1927: The president receives several state officials and a delegation from the National Women's Party, which is promoting an equal rights amendment to the U.S. Constitution.

July 16, 1927: The Coolidges attend the annual Tri-State Farmers Picnic at the U.S. Experiment Farm near Ardmore.

July 18, 1927: Hanford McNider, assistant secretary of war, arrives to meet with the president.

July 20, 1927: Herbert Hoover, secretary of commerce, arrives to meet with the president.

July 21, 1927: Senator Reed Smoot, of Utah, arrives for a visit. Hoover and the president visit the State Trout Hatchery in Rapid City. C.W. Pugsley, president of South Dakota State College, and his wife stay overnight at the Game Lodge.

July 22, 1927: The president receives a group of children from Camp Wanzer, a Black Hills camp for children affected by tuberculosis.

July 23, 1927: Traveling by train to Mystic and then by lumber wagon, the Coolidges visit former Nebraska governor Samuel McKelvie and his wife at their summer cabin.

July 26, 1927: The president of the National Creamery Buttermakers Association and officers and directors of the State Dairy Association present the president with a twenty-five-pound tub of butter. Mrs. Coolidge goes to Newcastle, Wyoming, for the wedding of Dorothy Mondell, daughter of former congressman Frank Mondell.

July 27, 1927: The Coolidges attended the Gold Discovery Pageant at Custer.

July 29, 1927: Frank T. Hines, head of the U.S. Veterans Bureau, visits the president.

August 1, 1927: U.S. senator Arthur Capper, of Kansas, arrives to visit with the president.

August 2, 1927: President Coolidge announces at Rapid City High School, on the fourth anniversary of his elevation to the presidency, that he will not run for reelection in 1928.

August 4, 1927: The Coolidges attend the Days of '76 celebration in Deadwood, where Sioux people place a headdress on the president and make him an honorary member of the Sioux Nation.

August 8, 1927: Curtis D. Wilbur, secretary of the navy, arrives to visit the president.

August 9, 1927: U.S. senator Simeon Fess, of Ohio, and U.S. representative W.E. Hull, of Illinois, visit the president. He also receives a delegation from the Woman's Christian Temperance Union.

August 10, 1927: President Coolidge rides a horse to the base of Mount Rushmore and speaks at a ceremony marking the start of the carving of four presidential faces into the mountainside.

August 11, 1927: Mrs. Coolidge dedicates a recently completed Custer community building sponsored by the Women's Civic Club of Custer.

August 12, 1927: Secretary of Labor James Davis; Eugene Meyer, head of the Federal Farm Labor Board; and Herbert Lord, director of the budget, meet with the president. He also receives one hundred local children, members of the Loyal Temperance League.

August 14, 1927: John Coolidge arrives in the Black Hills to spend time with his parents.

August 15, 1927: Carl Y. Schoneman, assistant secretary of the treasury, and John H. Bartlett, first assistant postmaster general, visit the president.

August 16, 1927: General John J. Pershing arrives to see the president. Representatives of the South Dakota Elks Association present the first couple with a buffalo robe.

August 17, 1927: The Coolidges visit the Pine Ridge Indian Reservation.

August 18, 1927: The Coolidges travel with their son, John, to Hot Springs in the southern Black Hills, where they visit Battle Mountain Sanitarium, a federal facility for disabled soldiers, along with the State Soldiers Home and the Hot Springs Country Club.

August 19, 1927: Dwight Morrow, a longtime friend of the president who is soon to be appointed ambassador to Mexico, arrives for a visit.

August 20, 1927: U.S. senator Peter Norbeck, of South Dakota, and his wife entertain the first couple and their son, John, at the Norbecks' cabin near the Game Lodge.

August 21–28, 1927: The Coolidges, transported by train, spend a week in Yellowstone National Park.

August 30, 1927: The president receives a delegation of South Dakota regents. He also receives U.S. senator Wesley Jones, of Washington, and a delegation from the American Society of Agricultural Engineers to discuss irrigation in the Columbia River basin.

August 31, 1927: President Coolidge attends the dedication of the Camp Coolidge State Boy Scout Camp in Custer State Park.

September 1, 1927: The first couple and their son, John, visit Newell to inspect an irrigation district and then visit the Butte County Fair at Nisland. The president gives a brief impromptu speech and is presented with two sheep and an irrigator's miniature shovel made of gold.

September 2, 1927: Charles Lindbergh flies over the State Game Lodge and Rapid City in the *Spirit of St. Louis* while on a nationwide tour.

September 3, 1927: The Coolidges host the congregation from the Hermosa Congregational Church at the State Game Lodge.

September 5, 1927: U.S. senator Hiram Bingham, of Connecticut, arrives to visit the president.

September 6, 1927: The Fortnightly Club of Rapid City hosts a reception for Grace Coolidge at the clubhouse on the grounds of the Rapid City Country Club.

September 7, 1927: On the Game Lodge lawn, Coolidge reviews the soldiers delegated from Fort Meade who guarded the Game Lodge during the summer. The Coolidges celebrate the twenty-first birthday of their son, John, with him at the Game Lodge.

September 8, 1927: President and Mrs. Coolidge visit the museum of the South Dakota State School of Mines in Rapid City, and John Coolidge takes an automobile tour of the Badlands.

September 9, 1927: On their last day in the Black Hills, the Coolidges let it be known that they will receive an audience in front of Rapid City High School, where a throng of thousands gathers to hear the president express his gratitude for a summer's worth of hospitality. The presidential train departs Rapid City that evening.

September 10, 1927: The Coolidges stop in Brookings, South Dakota, where President Coolidge dedicates Coolidge Sylvan Theatre and

Lincoln Memorial Library at South Dakota State College and is named an honorary doctor of science.

September 11, 1927: The Coolidges arrive in Washington, D.C., having been gone ninety days.

February 25, 1929: President Coolidge signs a bill pledging $250,000 in federal funding for the carving of Mount Rushmore.

March 4, 1929: On his last day in office, President Coolidge signs a bill designating part of South Dakota's Badlands as a national monument.

January 5, 1933: Calvin Coolidge dies of a heart attack at his home in Massachusetts.

Notes

Introduction

1. Shelta, National Register of Historic Places Inventory.
2. Unless otherwise noted, details and descriptions of August 2, 1927, are from these accounts: John T. Lambert, "The Presidential News Service," *Black Hills Engineer*; Fuess, *Calvin Coolidge*, 228–30; "President Acted Alone," *New York Times*, August 3, 1927; Phillip Kinsley, "'Choose Not to Run' Note Stirs Whole Country," *Chicago Daily Tribune*, August 3, 1927; Associated Press, "'I Do Not Choose to Run,' Says Coolidge Statement," *Pittsburgh Post-Gazette*, August 3, 1927; International News Service, "He Renounces All Claim to 1928 Support," *Telegraph-Herald*, August 2, 1927; "Coolidge Does Not Choose to Be 1928 Candidate," *Rapid City Journal*, August 2, 1927; and Quint and Ferrell, *Talkative President*, 75–76.
3. Coolidge's morning habits are from Charles R. Michael, "In the Black Hills the President Finds Opportunity to Consider the Farm Question at Close Range—Good Fishing and Walking Give Him Recreation—How He and Mrs. Coolidge Spend Their Day," *New York Times*, July 10, 1927; and Coolidge, *Autobiography*, 200–201.
4. Fuess, *Calvin Coolidge*, 229.
5. Greenberg, *Calvin Coolidge*, 10.
6. Michael, "In the Black Hills."
7. Quint and Ferrell, *Talkative President*, 75.
8. Associated Press, "'I Do Not Choose to Run,' Says Coolidge Statement."

CHAPTER 1

9. L.C. Speers, "Farm Bill Veto Opens the 1928 Battle," *New York Times*, March 6, 1927.

10. Albert M. Jackley to William Williamson, March 10, 1926, Williamson Papers, Box 25, University of South Dakota Archives and Special Collections. For readability, some errors in Jackley's letter have been corrected. This is the actual text of the letter: "There is no possible way in which our President or the Government could so forcefully show it's [*sic*] appreciation of conditions in the west than by establishing the Summer White House in the Black Hills. The inconveniences would undoubtedly be foreborn [*sic*] cheerfully, and universally approved. You have a good case and I feel sure it will be well presented by you."

11. Albert Jackley, incidentally, is no relation to modern South Dakota attorney general Marty Jackley, according to Lance Nixon, "Mr. Jackley's War: 'St. Patrick of South Dakota' Attacked Rattlesnakes in Their Strongholds," *Capital Journal*, April 19, 2013, http://www.capjournal.com/news/mr-jackley-s-war-st-patrick-of-south-dakota-attacked/article_d3e92998-a8b2-11e2-accb-001a4bcf887a.html. Coolidge's fear of snakes is mentioned by multiple sources, including Starling and Sugrue, *Starling of the White House*, 246.

12. Francis Case to William Williamson, telegram, March 30, 1926, Williamson Papers, Box 25, University of South Dakota Archives and Special Collections. For readability, the telegram has been edited from its original, unpunctuated, all-caps form. This is the actual text: "PRESS DISPATCHES SAY PRESIDENT COOLIDGE WILL NOT RETURN TO SWAMPSCOTT THIS SUMMER DESIRING MOUNTAINS PLEASE PRESENT SUPERIOR CLIMATE TEMPERATE ALTITUDE ACCESSIBILITY AND COMMUNICATION FACILITIES BLACKHILLS PARTICULARLY STATE PARK AND LEARN EXACT REQUIREMENTS CONFIDENT ASSOCIATED COMMERCIAL CLUBS AND PARK BOARD WILL PROVIDE WHATEVER NECESSARY TO ESTABLISH SUMMER WHITEHOUSE IN BLACKHILLS WESTERN SUMMER HOME MEANS MUCH FOR ENTIRE COUNTRY."

13. William Williamson to Calvin Coolidge, April 1, 1926, Williamson Papers, Box 25, University of South Dakota Archives and Special Collections.

14. Everett Sanders to William Williamson, April 1, 1926, Williamson Papers, Box 25, University of South Dakota Archives and Special Collections.

15. Williamson, *William Williamson*, 188.

16. *Black Hills Engineer*, President Coolidge Number, 211–12.

17. Arthur Krock, "Corn-Belt Politics," *New York Times*, June 9, 1927.
18. "Coolidge Chooses West for Vacation," *New York Times*, March 9, 1927.
19. Ibid.
20. Speers, "Farm Bill Veto Opens the 1928 Battle."

Chapter 2

21. Peter Norbeck to C.A. Christopherson, telegram, May 28, 1927, Norbeck Papers, Box 12, Folder 2, University of South Dakota Archives and Special Collections.
22. Fite, *Peter Norbeck*, 114.
23. Norbeck's ally was Chet Leedom, who'd managed the successful 1924 U.S. Senate campaign of Norbeck's former lieutenant governor William McMaster. Coolidge was reluctant to appoint Leedom, a reputed drinker whose duties as marshal would include enforcing Prohibition. The story of Coolidge's veiled ultimatum regarding the postal bill veto and Norbeck's response is mentioned in Fite, *Peter Norbeck*, 117, and in greater detail in Williamson, *William Williamson*, 165–70.
24. "Yankee horse trading" is the term applied to Coolidge's negotiation style in Williamson, *William Williamson*, 165.
25. "Norbeck Content Winning Coolidge; Chicago Daily News Pays Compliment to South Dakota's Senior Senator," *Gate City Guide*, June 17, 1927.
26. All details of the friendship between Grace Coolidge and Lydia Norbeck are from Koupal, "Lydia Norbeck's 'Recollections of the Years.'"
27. Williamson, *William Williamson*, 190.
28. Starling and Sugrue, *Starling of the White House*, 248.
29. Various letters and telegrams, Norbeck Papers, Box 12, Folders 1–2, University of South Dakota Archives and Special Collections.
30. Norbeck to Christopherson, telegram.
31. John A. Stanley, "Preparing the Presidential Home in the State Park," *Black Hills Engineer*, 248.

Chapter 3

32. Ibid., 250.
33. Associated Press, "Coolidge Will Arrive June 16," *Rapid City Journal*, May 31, 1927.

34. "State Appropriation for Park Improvements Asked," *Rapid City Journal*, May 31, 1927.

35. Summaries and descriptions of the preparations for the presidential visit are taken from *Rapid City Journal*, May 24–June 15, 1927; *Gate City Guide*, May 20 and 27, June 3 and 10, 1927; and *Black Hills Engineer*, President Coolidge Number, November 1927.

36. Associated Press, "Stay in Black Hills Raises Problems," *New York Times*, June 4, 1927.

37. Untitled editorial, *Rapid City Journal*, June 6, 1927.

38. Starling and Sugrue, *Starling of the White House*, 249.

39. William Bulow, "When Cal Coolidge Came to Visit Us," *Saturday Evening Post*, January 4, 1947.

40. The men and truck numbers are from *Rapid City Journal*, June 1 and 6, 1927; the recollection of the road being finished on June 15 is from Starling and Sugrue, *Starling of the White House*, 249.

41. Starling and Sugrue, *Starling of the White House*, 249.

Chapter 4

42. Associated Press, "Presidential Special Leaves Tonight for Black Hills," *Rapid City Journal*, June 13, 1927.

43. There is a popular myth that the Coolidges planned a short South Dakota vacation and then extended it because they liked the Black Hills so well. The origin of the myth might be then governor William Bulow, who wrote in his January 4, 1947 *Saturday Evening Post* article, titled "When Cal Coolidge Came to Visit Us," that the president "stayed more than twice as long in his summer home in the Black Hills as he originally planned." Many other sources indicate that the Coolidges always planned to stay the entire summer, such as this one: "President Coolidge and Party Will Arrive in Rapid City June 16th—Stay Two or Three Months," *Gate City Guide*, June 3, 1927.

44. Associated Press, "Coolidge Okehs [*sic*] Reception Plan at Capital City," *Rapid City Journal*, June 14, 1927.

45. Ellen Agnes Riley to Adell G. Carpenter Riley, transcription of letter, July 24, 1927, Ellen Agnes Riley White House Papers, MSA 632: Folder 8, Leahy Library, Vermont Historical Society.

46. "Coolidge Reaches His Vacation Lodge in the Black Hills," *New York Times*, June 16, 1927.

47. Ibid.; "Farm Bill Text Out; Coolidge Studies It," *New York Times*, August 7, 1927.
48. The Coolidge-Brewer relationships are from Shlaes, *Coolidge*, 380; Brewer Ancestry of President Calvin Coolidge; and Milan B. Brewer, Find a Grave website.
49. Associated Press, "Pierre Accords U.S. Executive Joyful Greeting," *Rapid City Journal*, June 15, 1927.
50. Ibid.; "Millionaire Chauffeur Given Dime Tip by Guest," *Rapid City Journal*, June 16, 1927.
51. "Coolidge Reaches His Vacation Lodge in the Black Hills."
52. The account of Bulow's interaction with the president in Pierre is from Bulow, "When Cal Coolidge Came to Visit Us."
53. Quint and Ferrell, *Talkative President*, 48.
54. *Washington Star*, "Coolidge in the Black Hills," *Rapid City Journal*, June 2, 1927.

CHAPTER 5

55. "Coolidge Reaches His Vacation Lodge in the Black Hills."
56. Throughout this chapter, unless otherwise noted, details of Coolidge's arrival at Rapid City and the State Game Lodge are taken from various stories in the June 16, 1927 edition of the *Rapid City Journal*; the June 17, 1927 edition of the *Gate City Guide*; and "Coolidge Reaches His Vacation Lodge in the Black Hills."
57. "Coolidge Reaches His Vacation Lodge in the Black Hills."
58. Ibid.
59. Quint and Ferrell, *Talkative President*, 48.
60. "Lowden's Backers Define His Policies," *New York Times*, June 16, 1927.

CHAPTER 6

61. Bulow, "When Cal Coolidge Came to Visit Us."
62. Unless otherwise noted, details throughout this chapter about the president's fishing efforts on his first day in the Black Hills are from "Coolidge Catches Seven Fine Trout," *New York Times*, June 17, 1927; "President and Mrs. Coolidge Appear Pleased," *Rapid City Journal*, June 16, 1927; and Associated Press, "National Executive Enjoys Waltonian Sport; Yanks Out Five Rainbows from Stream," *Rapid City Journal*, June 16, 1927.

63. C.C. O'Harra, "President Coolidge in the Black Hills," *Black Hills Engineer*, 220–21.

64. Starling and Sugrue, *Starling of the White House*, 236–41.

65. Boone, Chapter on President Coolidge from the Memoirs of His Physician, 1963–1965, 576; Hoover, *Forty-Two Years in the White House*, 131.

66. "Inspection Tour of Park Complete," *Rapid City Journal*, May 13, 1927.

67. Coolidge, *Autobiography*, 221. Coolidge seems to indicate in this passage that Prudence Prim was buried near Bear Butte, possibly on the grounds of Fort Meade where the dog was treated, but no conclusive reports of a burial location could be found.

68. "Coolidge Catches Seven Fine Trout."

69. Ibid.

70. Ibid.

71. Ibid.

72. The "That's enough" quote and Coolidge's description of all seven fish as his own are from "Coolidge Catches Seven Fine Trout"; the clarification that five of the fish were caught by Coolidge and two by Starling is from "President and Mrs. Coolidge Appear Pleased."

73. Quint and Ferrell, *Talkative President*, 48.

74. Bulow's account and all quotations attributed to him in this chapter are from Bulow, "When Cal Coolidge Came to Visit Us"; Starling's account is from Starling and Sugrue, *Starling of the White House*, 250.

75. Grace Coolidge to E.H. Lighter, May 7, 1947, Senator Francis H. Case Collection, McGovern Library, Dakota Wesleyan University.

CHAPTER 7

76. "President Hears Boy's First Sermon," *New York Times*, June 20, 1927.

77. Unless otherwise noted, all details about Rolf Lium and the Coolidges' first visit to the Hermosa Church are from these sources: "Coolidge Goes to Hermosa Church," *Gate City Guide*, June 24, 1927; "President Hears Boy's First Sermon"; "National Executive and Wife Attend Hermosa Church Sunday," *Rapid City Journal*, June 20, 1927; and Philip Kinsley, "Coolidges Hear Boy Preacher's First Sermon," *Chicago Daily Tribune*, June 20, 1927.

78. Quotes are from "National Executive and Wife Attend Hermosa Church Sunday."

79. "President Hears Boy's First Sermon."

80. "National Executive and Wife Attend Hermosa Church Sunday."

81. The recollections about the ribbons tied to the Coolidges' chair backs and their habit of leaving an empty seat between them are from Geraldine Evans, "Young Pastor Was Surprised by a VIP in Church," *Country Churches*, date unknown, Hermosa United Church of Christ archives.

82. "President Hears Boy's First Sermon."

83. Ibid.

84. Ibid.

85. "Coolidge Pastor Is Chemistry Pupil Trying Preaching."

86. "Lindbergh and Lium."

87. "Coolidge's Church Searched for Bombs," *New York Times*, August 8, 1927.

88. "Rolf Lium: President Coolidge's Black Hills Pastor."

89. Details of Lium's later life are from these sources: "Lium Medical Alumni Head," *Harvard Crimson*, May 31, 1958, http://www.thecrimson.com/article/1958/5/31/lium-medical-alumni-head-pat-the; Annual Report of the Selectmen and Other Officers for the Year Ended December 31, 1986, Town of Rye, New Hampshire, http://www.archive.org/stream/annualreportofto1986ryen/annualreportofto1986ryen_djvu.txt; and Tri-State Regional Medical Program.

CHAPTER 8

90. Boone, Chapter on President Coolidge from the Memoirs of His Physician, 840.

91. Coolidge, *Autobiography*, 93.

92. Ferrell, *Grace Coolidge*, 104–11.

93. Fuess, *Calvin Coolidge*, 276.

94. Unless otherwise noted, descriptions of the hiking incident are from Associated Press, "Mrs. Coolidge's Hike Causes Late Luncheon," *New York Times*, June 28, 1927, and from "Mrs. Coolidge Takes Morning for Long Hike," *Rapid City Journal*, June 27, 1927.

95. Boone, Chapter on President Coolidge from the Memoirs of His Physician, 840.

96. The nature of Coolidge's press conferences is covered at length throughout Quint and Ferrell, *Talkative President*.

97. Ibid., 51.

98. "President Suggests Methods to Reporters," *New York Times*, June 29, 1927.

99. Associated Press, "Haley Returns to Washington," *Rapid City Journal*, June 29, 1927.

100. Boone, Chapter on President Coolidge from the Memoirs of His Physician, 849.

101. Ibid., 847.

102. Ibid., 841.

103. Associated Press, "Asks New Name for Squaw Creek," *Rapid City Journal*, June 28, 1927.

104. Boone, Chapter on President Coolidge from the Memoirs of His Physician, 849.

105. Rodney Dutcher, "Washington Is Place for Great and Small and Coolidges Visit Joneses," *Evening News*, November 2, 1927.

CHAPTER 9

106. C.E. O'Connor, "The Presidential Air Mail," *Black Hills Engineer*, 255.

107. Ibid., 254–57.

108. Ibid.

109. Bilstein, *Flight Patterns*, 40.

110. O'Connor, "Presidential Air Mail," 254–57; "Coolidges Escape Severe Hail Storm by Fast Auto Ride," *New York Times*, June 18, 1927.

111. "Damage by Hail Storm Limited to Small Area," *Rapid City Journal*, June 18, 1927.

112. "Coolidges Escape Severe Hail Storm by Fast Auto Ride."

113. Ibid.

114. Ibid.

115. Ibid.

116. O'Connor, "Presidential Air Mail," 254–57.

117. Ibid.

118. Ibid.

119. Associated Press, "Carrier of President's Mail Finds Old Friend," *Rapid City Journal*, June 30, 1927.

120. O'Connor, "Presidential Air Mail," 254–57.

121. Ibid.

122. "Drops Wreath on Lawn at Lodge," *Rapid City Journal*, June 23, 1927.

123. Ellen Agnes Riley to Adell G. Carpenter Riley, transcription of letter, September 24, 1927, Ellen Agnes Riley White House Papers, MSA 632: Folder 8, Leahy Library, Vermont Historical Society.

124. "'Lindy' Visits Hills Today on Way to Cheyenne," *Rapid City Journal*, September 2, 1927.

125. "Rapid City Saw Epochal Morning," *Rapid City Journal*, September 2, 1927.
126. "Coolidges Depart from Rapid City," *New York Times*, September 10, 1927.

Chapter 10

127. *Omaha World-Herald*, "The West and Mr. Coolidge," *Gate City Guide*, May 27, 1927.
128. Details of the journey to the McKelvie cabin and the activities there are from "Coolidge Pans Gold, Poses for Pictures as Trout Fisherman," *New York Times*, July 24, 1927, and "President Jerks Coat and Helps Push Lumber Wagon Over Steep Mountain Road," *Rapid City Journal*, July 23, 1927.
129. Details of the president's July 4 birthday party are from "Custer Boy Scouts Give Cowboy Outfit to Coolidge" and "Sidelights of the President's Birthday Party at the Game Lodge," *Rapid City Journal*, July 5, 1927, and from "Coolidge as Cowboy Wins West's Heart," *New York Times*, July 5, 1927.
130. "Coolidge as Cowboy Wins West's Heart."
131. "Sidelights of the President's Birthday Party at the Game Lodge."
132. "Coolidge as Cowboy Wins West's Heart."
133. "Sidelights of the President's Birthday Party at the Game Lodge."
134. "Coolidge as Cowboy Wins West's Heart."
135. Ibid.
136. Unless otherwise noted, details of the Coolidge's attendance at the Belle Fourche Roundup are from "President Coolidge Attends Tri-State Roundup," *Rapid City Journal*, July 5, 1927, and from "Coolidge Attends Wild West Rodeo," *New York Times*, July 6, 1927.
137. "Coolidge Attends Wild West Rodeo."
138. Williamson, *William Williamson*, 193–94.
139. Associated Press, "Coolidge Rides His Horse," *New York Times*, July 7, 1927; "Coolidge Takes First Horseback Ride Yesterday," *Rapid City Journal*, July 7, 1927.
140. Starling and Sugrue, *Starling of the White House*, 254.
141. Edward T. Clark to Frank W. Stearns, July 12, 1927, Materials for a Proposed Biography of Frank Waterman Stearns, Amherst College Library Archives and Special Collections.

CHAPTER 11

142. "Coolidge Addresses 10,000 Sioux Indians as Supreme Chief," *New York Times*, August 18, 1927.

143. "President and Mrs. Coolidge Visit Indian School," *Rapid City Journal*, July 7, 1927.

144. "Coolidge Becomes Chief of the Sioux," *New York Times*, August 5, 1927.

145. Weinberg, "Preface," *Real Rosebud*, xiii–xiv.

146. "Coolidge Views Panorama of Black Hills History," *Rapid City Journal*, July 27, 1927.

147. "Coolidges Witness Gold Rush Pageant," *New York Times*, July 28, 1927.

148. "Coolidge Becomes Chief of the Sioux."

149. Ibid.

150. Ibid.; "Sioux Indians Pay Highest Tribute to Coolidge," *Rapid City Journal*, August 4, 1927.

151. "Short Bull, Red Chieftain, Stirs Up Controversy," *Rapid City Journal*, August 13, 1927.

152. Walter Travis, "Close-Up View Given Today of Indian Life," *Rapid City Journal*, August 17, 1927.

153. "Coolidge Addresses 10,000 Sioux Indians as Supreme Chief."

154. Ellen Agnes Riley to Adell G. Carpenter Riley, transcription of letter, August 21, 1927, Ellen Agnes Riley White House Papers, MSA 632: Folder 8, Leahy Library, Vermont Historical Society.

155. Ibid.

156. "Coolidge Addresses 10,000 Sioux Indians as Supreme Chief."

157. Ibid.

158. Ibid.

159. Peter Norbeck to Charles H. Burke, August 1, 1927, Norbeck Papers, Box 12, Folder 4, University of South Dakota Archives and Special Collections.

CHAPTER 12

160. Fite, *Mount Rushmore*, 76.

161. Smith, *Carving of Mount Rushmore*, 122.

162. Associated Press, "Rushmore Work Soon Under Way," *Rapid City Journal*, July 26, 1927.

163. Williamson, *William Williamson*, 239.

164. "President Will Watch Start of Actual Carving," *Rapid City Journal*, August 6, 1927.

165. Smith, *Carving of Mount Rushmore*, 151.

166. "Coolidge Praises Project as National Monument to Symbolize Patriotic Deeds," *Rapid City Journal*, August 10, 1927.

167. Descriptions and quotes from the Mount Rushmore ceremony, unless otherwise noted, are from "Coolidge Praises Project as National Monument to Symbolize Patriotic Deeds," *Rapid City Journal*, August 10, 1927, and from "Coolidge Dedicates Mountain Memorial to Four Presidents," *New York Times*, August 11, 1927.

168. Greenberg, *Calvin Coolidge*, 67.

169. Coolidge, *Autobiography*, 182.

170. Julin, *Marvelous Hundred Square Miles*, 99.

171. Ibid.

172. Smith, *Carving of Mount Rushmore*, 124.

173. Taliaferro, *Great White Fathers*, 218.

174. Park Statistics, Mount Rushmore National Memorial website; Tourism Economics, "Economic Impact of Tourism in South Dakota."

Chapter 13

175. Ross, *Grace Coolidge and Her Era*, 222.

176. Starling and Sugrue, *Starling of the White House*, 248.

177. Fuess, *Calvin Coolidge*, 229.

178. Ibid.

179. Ibid.

180. Starling and Sugrue, *Starling of the White House*, 259.

181. Ibid.

182. "Coolidge Not Out, Slemp Believes," *New York Times*, September 10, 1927.

183. Ellen Agnes Riley to Adell G. Carpenter Riley, transcription of letter, September 9, 1927, Ellen Agnes Riley White House Papers, MSA 632: Folder 8, Leahy Library, Vermont Historical Society.

184. "Coolidges Depart from Rapid City," *New York Times*, September 10, 1927.

Chapter 14

185. Fite, *Peter Norbeck*, 129.

186. Coolidge, *Autobiography*, 239.

187. Ibid., 240.

188. Ibid., 190, 197.

189. Edward T. Clark to Frank W. Stearns, June 29, 1927, Materials for a Proposed Biography of Frank Waterman Stearns, Amherst College Library Archives and Special Collections.

190. Walter Travis, "Middle West's Views on Farm Aid Mixed?" *Rapid City Journal*, July 15, 1927.

191. "Year's Rainfall Near 22 Inches," *Rapid City Journal*, August 22, 1927.

192. *Capital Journal*, "Crops," *Rapid City Journal*, July 25, 1927.

193. "Coolidges Depart from Rapid City," *New York Times*, September 10, 1927.

194. "West River Is Spot Where Tall Corn Grows," *Rapid City Journal*, August 29, 1927.

195. Ferrell, *Grace Coolidge*, 113.

196. "President Acted Alone," *New York Times*, August 3, 1927.

197. Julin, *Marvelous Hundred Square Miles*, 83.

198. Ibid.

Chapter 15

199. "Senator Norbeck Arrives in Rapid City Tuesday," *Gate City Guide*, June 10, 1927.

200. "Coolidge to Start for Home Tonight," *New York Times*, September 9, 1927.

201. Badlands Natural History Association, *History of Badlands National Monument*.

202. Seth Tupper, "Banner Year in the Boondocks: Visitation Soars at Missile Site, Badlands," *Rapid City Journal*, February 22, 2016.

203. "2,117,205 Words Wired on the Coolidge Vacation," *New York Times*, September 10, 1927.

204. "Many Thousands of Words Sent," *Rapid City Journal*, September 8, 1927.

205. *Pioneer-Times*, untitled guest editorial, *Rapid City Journal*, June 16, 1927.

206. "Tourists More Numerous This Year Than Last," *Gate City Guide*, June 24, 1927.

207. "400 Tourists Stop at Club Daily, Say," *Rapid City Journal*, July 16, 1927.

208. "Tourist Travel Shows Increase," *Rapid City Journal*, August 31, 1927.

209. "Huge Caravan of Autos Is Coming," *Rapid City Journal*, July 18, 1927.

210. "June Saw Huge Gas Tax Income," *Rapid City Journal*, August 3, 1927.

211. Associated Press, "Surfaced Road Across State in 1928 Is Aim," *Rapid City Journal*, August 18, 1927.

212. *Jerseyman*, "The Black Hills Workshop," *Rapid City Journal*, September 1, 1927.

213. Historic marker at site of Rapid City High School.
214. "President Is in Love with the Black Hills," *Gate City Guide*, June 24, 1927.

TIMELINE

215. The source for any timeline items not previously mentioned in this book is "Chronicle of President Coolidge's Summer in the Black Hills," *Black Hills Engineer*, President Coolidge Number, 289–93.

Bibliography

Books

Bilstein, Roger E. *Flight Patterns: Trends of Aeronautical Development in the United States, 1918–1929*. Athens: University of Georgia Press, 2008.

Coolidge, Calvin. *The Autobiography of Calvin Coolidge*. New York: Cosmopolitan Book Corporation, 1929.

Ferrell, Robert H. *Grace Coolidge: The People's Lady in Silent Cal's White House*. Lawrence: University Press of Kansas, 2008.

Fite, Gilbert C. *Mount Rushmore*. Norman: University of Oklahoma Press, 1952.

————. *Peter Norbeck: Prairie Statesman*. Pierre: South Dakota State Historical Society Press, 2005.

Fuess, Claude Moore. *Calvin Coolidge: The Man from Vermont*. Boston: Little, Brown and Company, 1940.

Greenberg, David. *Calvin Coolidge*. New York: Times Books, 2006.

Hoover, Irwin "Ike" Hood. *Forty-Two Years in the White House*. Cambridge, MA: Houghton Mifflin Company, Riverside Press, 1934.

Julin, Suzanne Barta. *A Marvelous Hundred Square Miles: Black Hills Tourism, 1880–1941*. Pierre: South Dakota State Historical Society Press, 2009.

Quint, Howard H., and Ferrell, Robert H. *The Talkative President: The Off-the-Record Press Conferences of Calvin Coolidge*. Amherst: University of Massachusetts Press, 1964.

Ross, Ishbel. *Grace Coolidge and Her Era: The Story of a President's Wife*. Plymouth, VT: Calvin Coolidge Memorial Foundation, 1988.

Shlaes, Amity. *Coolidge*. New York: Harper, 2013.

Smith, Rex Alan. *The Carving of Mount Rushmore*. New York: Abbeville Press, 1985.

Starling, Edmund W., and Thomas Sugrue. *Starling of the White House: The Story of the Man Whose Secret Service Detail Guarded Five Presidents from Woodrow Wilson to Franklin D. Roosevelt*. New York: Simon and Schuster, 1946.

Taliaferro, John. *Great White Fathers: The Story of the Obsessive Quest to Create Mount Rushmore*. New York: PublicAffairs, 2002.

Weinberg, Marjorie. *The Real Rosebud: The Triumph of a Lakota Woman*. Lincoln: University of Nebraska Press, 2004.

Williamson, William. *William Williamson: Student, Homesteader, Teacher, Lawyer, Judge, Congressman and Trusted Friend; An Autobiography*. Privately printed, Chicago and Crawford, Illinois: Lakeside Press, R.R. Donnelley & Sons Company, 1964.

MANUSCRIPTS

Bellamy, Paul E., Papers. Richardson Collection, University of South Dakota Archives and Special Collections.

Boone, Joel T. Chapter on President Coolidge from the Memoirs of His Physician, 1963–1965. Joel T. Boone Papers, Library of Congress, American Memory website. https://memory.loc.gov.

Case, Francis H., Collection. McGovern Library, Dakota Wesleyan University.

Norbeck, Peter, Papers. Richardson Collection, University of South Dakota Archives and Special Collections.

Riley, Ellen Agnes, White House Papers, 1926–1961. Leahy Library, Vermont Historical Society.

Stearns, Frank Waterman, Correspondence with White House, June–September 1927. In Fuess, Materials for a Proposed Biography of Frank Waterman Stearns, Amherst College Library Archives and Special Collections, Box 1, Folder 5.

Williamson, William, Papers. Richardson Collection, University of South Dakota Archives and Special Collections.

Newspapers

Capital Journal (Pierre, SD), www.capjournal.com.

Chicago Daily Tribune, Chicago Tribune Archives, http://archives.chicagotribune.com.

Evening News (San Jose, CA), Google News Archive, https://news.google.com/newspapers.

Gate City Guide (Rapid City, SD), Rapid City Public Library microfilm.

Harvard Crimson, http://www.thecrimson.com.

New York Times, TimesMachine, http://timesmachine.nytimes.com.

Pittsburgh Post-Gazette, Google News Archive, https://news.google.com/newspapers.

Rapid City Journal, Rapid City (SD) Public Library microfilm.

Telegraph-Herald (Dubuque, IA), Google News Archive, https://news.google.com/newspapers.

Other

Annual Report of the Selectmen and Other Officers for the Year Ended December 31, 1986, Town of Rye, New Hampshire. http://www.archive. org/stream/annualreportofto1986ryen/annualreportofto1986ryen_djvu.txt.

Archives of the Hermosa (SD) United Church of Christ.

Badlands Natural History Association. *History of Badlands National Monument.* 1968. National Park Service website. https://www.nps.gov/parkhistory/ online_books/badl/contents.htm.

Black Hills Engineer (South Dakota State School of Mines, Rapid City). President Coolidge Number. November 1927. Digital Library of South Dakota, Campus Archives, SDSMT. http://dlsd.sdln.net/cdm/ref/ collection/sdsmt/id/25281.

Brewer Ancestry of President Calvin Coolidge. RootsWeb website. http:// freepages.genealogy.rootsweb.ancestry.com/~brouwergenealogydata/ Research/breweranccalvincoolidge.pdf.

Bulow, William. "When Cal Coolidge Came to Visit Us." *Saturday Evening Post*, January 4, 1947.

"Coolidge Pastor Is Chemistry Pupil Trying Preaching." Newspaper clipping dated June 20, 1927. Northfield Organizations scrapbook, Page 107. Northfield History Collaborative collection, Northfield (MN) Public Library. https://contentdm.carleton.edu/cdm/ref/collection/NfldLibrary/id/3417.

Koupal, Nancy Tystad, ed. "Lydia Norbeck's 'Recollections of the Years.'" *South Dakota Historical Collections* 39 (1979): 1–147.

"Lindbergh and Lium." Brochure, *The Congregational Church Extension Boards*, date unknown. Chautauqua Brochures, Redpath Chautauqua Collection, Special Collections Department, University of Iowa Libraries. http:// digital.lib.uiowa.edu/cdm/ref/collection/tc/id/48743.

Milan B. Brewer. Find a Grave website. http://www.findagrave.com/cgi-bin/fg.cgi?page=gr&GRid=119371187.

Park Statistics. Mount Rushmore National Memorial website. https://www.nps.gov/moru/learn/management/statistics.htm.

"Rolf Lium: President Coolidge's Black Hills Pastor." Brochure, Redpath Bureau, 1928. Chautauqua Brochures, Redpath Chautauqua Collection, Special Collections Department, University of Iowa Libraries. http://digital.lib.uiowa.edu/cdm/ref/collection/tc/id/54526.

Shelta, David. National Register of Historic Places Inventory—Nomination Form. Custer State Game Lodge, June 11, 1981. http://focus.nps.gov/pdfhost/docs/NRHP/Text/83003007.pdf.

Tourism Economics. "The Economic Impact of Tourism in South Dakota: County and Region Analysis, Calendar Year 2015." South Dakota Department of Tourism website. http://www.sdvisit.com/tools/research/_pdf/15TSA_Tourism_Economics_Counties.pdf.

Tri-State Regional Medical Program. Medical Care and Education Foundation Inc. Boston, 1969. From Profiles in Science, National Library of Medicine. https://profiles.nlm.nih.gov/ps/access/RMAAXC.ocr.

INDEX

About the Author

Seth Tupper grew up in the small South Dakota towns of Wessington Springs and Kimball and earned a bachelor's degree in journalism from South Dakota State University in Brookings. He has worked for newspapers

The author atop Little Devils Tower within Custer State Park in the Black Hills of South Dakota. *Shelly Tupper.*

in Worthington, Minnesota, and Mitchell, South Dakota, and is currently an enterprise reporter for the *Rapid City Journal*. He has won numerous honors for his work, including the South Dakota Newspaper Association's 2007 Outstanding Young Journalist Award and the Public Notice Resource Center's 2014 National Public Notice Journalism Award. He lives in Rapid City with his wife, Shelly, and their children, Kaylie and Lincoln.